IMAGES
of America

WEST LINN

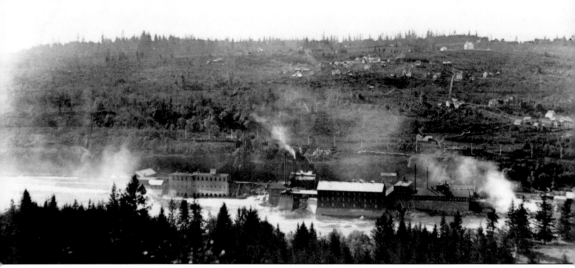

EARLY VIEW OF WEST LINN. West Oregon City—currently the Sunset area—is in the distance in this overview of 1899 West Linn. Above the paper mill runs the power line for the electric trolley to Willamette. The two-story Sunset School is in the middle to the right. The long line below it is the sidewalk, a wooden staircase built for children to walk up the hill. (Courtesy Clackamas Historical Society.)

ON THE COVER: DISCOVERER OF METEORITE. Bill Dale, on the left, stands by the Willamette Meteorite, which he and Ellis Hughes unearthed in West Linn in 1902. The boy on the right is Clark Hughes, son of Ellis and Phoebe Hughes. Bill Dale and Ellis Hughes were coming home from cutting wood for Willamette School the day they discovered the meteorite on land owned by Oregon Iron and Steel. Dale left to raise money to purchase the land but did not return right away; Ellis Hughes eventually asked Oregon Iron and Steel if he could buy the land, but when the company refused to sell, Hughes and friends decided to secretively move the meteorite onto his own property three-quarters of a mile away, which took about three months. He then charged visitors 25¢ per view, two of whom were attorneys for Oregon Iron and Steel, which sued in court and won to get the meteorite returned. (Courtesy Oregon Historical Society.)

IMAGES
of America

WEST LINN

Cornelia Becker Seigneur

ARCADIA
PUBLISHING

Published by Arcadia Publishing
Charleston, South Carolina

Printed in the United States of America

Library of Congress Catalog Card Number: 2008931752

For all general information contact Arcadia Publishing at:
Telephone 843-853-2070
Fax 843-853-0044
E-mail sales@arcadiapublishing.com
For customer service and orders:
Toll-Free 1-888-313-2665

Visit us on the Internet at www.arcadiapublishing.com

I dedicate this book
to my children,
Rachel Marianna,
Ryan Christopher,
Wesley David,
Michael Josef,
and Augustin
Heinz Martin;
to my husband,
Chris; and to
the community
of West Linn.

CONTENTS

ACKNOWLEDGMENTS

The best part about working on this book has been the wonderful community members I have met. A special thank you to the people whose photographs and stories I included: Mary Hill, Harold Gross, Lisa Younge Lawer, Sally McLarty, Patty Morgan, Glen and Rose Ek, Toni Dollowitch Bernert, Alan and Elsie Lewis, George Matile, John Klatt, Michael R. Anderson, David Banash, LaVerne Bagley Brown, H. J. Belton and Midori Hamilton, Dave and Judy Shipley, Betty Lind, Julie Buse Hugo, Maxine Buse, Esther Gross Betts, Marsha and Dick Gross, Carol Geldaker, Marge Logsdon, Renee Bagley Cleland, Rachelle and Clyde Bagley, Doug Tunnell, Marjorie White, Alma Coston, Mike Watters, Ruth Offer, Charles Awalt, Terri Loriaux, Tom Bernert, Bob Thorne, Mark Hanson, John Nilsen, Marla Baggetta, Davie Hume Kennerly, Dan Browne, Michael Harper, and Brandon Ebel.

Thanks to the following organizations for providing images: Tualatin Valley Fire and Rescue and Cassandra Ulven; U.S. Army Corps of Engineers, Portland, and Carol Hastings; West Linn Paper Company and Ian Dunlap; New Life Church and Scott Reavely; West Linn Lutheran Church and Myrth Williamson; Willamette United Methodist Church and Sharon Ryan; Willamette Christian Church and Loretta Howard and George Perdue; Emmanuel Presbyterian Church and Cathy Quakenbush and Joanna Bewley; West Linn Police and Terry Timeus and Neil Hennelly; West Linn Lions and Mike Watters; River View Lions; the City of West Linn; West Linn High School and Sue Bradley; West Linn Historic Resources Board; Willamette Falls Heritage; and Oregon Department of Transportation.

I am appreciative of the Clackamas County Historical Society, the Oregon Historical Society, and the Canby Historical Society for allowing me to use some of their images. Judy Chambers was helpful in finding photographs at the Clackamas Historical Society, and I am grateful to David Porter for his partnership on this project. I am also thankful that I am able to collaborate with the Oregon Historical Society, working with Scott Daniels and Lucy Berkley.

I am incredibly grateful for the careful eyes of my readers and research assistants, local historians John Klatt, David Banash, and Alan Lewis. For photography/technical support, my hat's off to Michael R. Anderson. For research and connection help, I thank Mike Gates; Sandy Carter of Willamette Falls Heritage; Cheryl Hill and Christine Siegel of the West Linn Public Library; Pat Rich, Chris Jordan, and Ken Worchester of the City of West Linn; Dick Pugh of Cascadia Meteorite Laboratory; Rick Bella of *The Oregonian* newspaper; Janet Goetze, freelance writer; and Jody Carson and Marsha and Dick Gross of the Willamette Centennial Committee. General thanks for connection and support are owed Mary Grace McDermott, Kathleen and Sarah Bernert, Kristin Tuor, and Gerry Winfield. I also appreciate the moral support of my writing from writer friends Samuel Greengard, Kathy Conrad, and Jeanie Higinbotham, as well as Amy Wang, my editor at *The Oregonian*, and Brian Monihan, publisher of *The West Linn Tidings*. And a huge nod is owed Mark Buser, former West Linn Chamber of Commerce president, for his early enthusiasm for my project, and for noting the international significance of the Willamette Meteorite to West Linn history.

At Arcadia, I would like to thank my editor, Tiffany Fray, for her efficiency and persistence and Sarah Higginbotham for her encouragement.

I am blessed with people who helped with my younger children while I concentrated on this project, especially Jeanie Higinbotham; Liz Wainwright; Joyce Milam; Breonna Winfield; Breonna Gerbasi; my sister, Sieglinde Kolberg; my son Ryan and daughter Rachel; my mother- and father-in-law, Nancy and David Seigneur; and my parents, Helmut and Margit Becker; my brother Martin and sister Sieglinde; and friends Judi Hickman and Bea Hansen for their support.

Finally, the support, patience, and love of my husband, Chris, and my five children, Rachel, Ryan, Wesley, Michael Josef, and Augustin, mean the world to me. I am humbly thankful to God for them and for guidance on this large project.

INTRODUCTION

West Linn sits on the Willamette Falls along the Willamette River, where Native American tribes gathered to fish and live before European settlement in the area. In 1840, Maj. Robert Moore, a colonist from Missouri and Illinois, arrived on the Oregon Trail as a member of the Peoria party from the state of Illinois. They were the first pioneers to travel the Oregon Trail in an attempt to create an expressly American colony in Oregon. At 58, Moore was the oldest member of the Peoria party that set out on May 1, 1839, to colonize the Oregon Country on behalf of the United States and to force out the English fur-trading companies operating there.

Moore was born in Pennsylvania on October 2, 1781, and, in 1805, he married Margaret Clark; they had 10 children. He had served as a major in the Pennsylvania Militia during the War of 1812. After moving to the Midwest with his family, he helped found several towns and businesses before heading out West. He joined the Shortess party when the Peoria Party split at Bent's Fort. Three of his 10 children eventually made the westward journey; his wife died in 1848 in Missouri.

Moore arrived in Oregon in 1840, finding the west side of the Willamette River near the falls, across from John McLoughlin's Oregon City. He purchased 1,000 acres of land from local inhabitants. Notably, he was one of the few to offer money to the Native Americans for their land. The Clowwewalla tribe, sometimes called the Wallamut or Willamette Falls tribe, led by Wanaxa, retained their fishing rights and homes on Moore's land. Moore's town, named "Robin's Nest," was platted in 1843, and on December 22, 1845, the Territorial Legislature of Oregon voted to rename Robin's Nest Linn City to honor Dr. Lewis Fields Linn, a U.S. senator from Missouri who, though he died in 1843, was the primary inspiration for the Donation Land Claim Act of 1850.

Within a few years of arriving, Moore had built flour and lumber mills, along with dwellings for mill workers, then known as mechanics. Soon there was a chair factory, a tavern, a wagon shop, and a gunsmith. He also fashioned a breakwater and portage basin. Robert Moore purchased an Oregon City newspaper, the *Spectator*, to promote his township. He encouraged Absalom H. Frier to run Linn City Hotel.

Besides Robert Moore's involvement in establishing Linn City, he was active on the territorial level. He voted for the provisional government at Champoeg in 1843 and was the chairman of the nine-member committee elected to frame the laws of the Oregon government. Moore died on September 2, 1857, never fully realizing what Linn City might become.

Other sections west of the falls were staked out simultaneously with Moore's. In 1842, Hugh Burns, a blacksmith from Ireland, platted his town to the north of Moore, calling it Multnomah City. This is now the Bolton neighborhood of West Linn. Burns was licensed to launch a ferry service between Multnomah City and Green Point in Oregon City beginning in 1844.

In the later part of the 1840s, Gabriel Walling staked out land in what is the current Robinwood area of West Linn, and his son Albert G. Walling claimed land in the area as well, eventually becoming one of Oregon's first publishers. Albert's brother George settled on property that became the Marylhurst area.

Moore's son James M. Moore claimed land in 1847 about 2 miles upstream from the mouth of the Tualatin River. Within two years, he built a lumber mill and gristmill. On January 8, 1850, a post office was established in Linn City with James M. Moore as the postmaster. Four years later, the office was discontinued. Marshall K. Perrin, Ambrose C. Fields, and his son Joseph A. Fields staked out property in the Willamette area and beyond in the 1840s. And Peter A. Weiss, who claimed land near the mouth of the Tualatin and Willamette Rivers, is the namesake for Pete's Mountain and the bridge over the Tualatin River that connects Willamette to Pete's Mountain. Samuel Miller and his wife, Rachael, claimed land near what are now Grapevine and Wisteria Roads.

Benjamin F. Baker purchased the Perrin Donation Land Claim in 1885, and the Fields Donation Land Claims were bought by Oregon Iron and Steel Company. In 1893, the Willamette Falls Electric Company purchased land from B. F. Baker and Oregon Iron and Steel with the express purpose of platting a town. This town, Willamette Falls (later shortened to Willamette), was created as a modern city with electricity and water.

Linn City, which had a population of 225 people in 1860, was washed away partially by a fire and then a flood in 1861. But the falls continued to draw industry, and the area would reinvent itself. In September 1868, the Willamette Falls Canal and Locks Company began work on a canal and locks at the west side of the falls to help river traffic travel around the falls. By the end of 1872, four locks had been fashioned to raise and lower ships a total of 40 feet. The steamship *Maria Wilkins* was the first vessel to navigate the locks on January 1, 1873.

In 1888, a suspension bridge was built to connect Oregon City to the west side of the river. Though Linn City was gone, higher up the bluff, West Oregon City—the current Sunset area—was developing, and the bridge provided a west-bank route to Oswego and Portland. In 1922, the current West Linn–Oregon City bridge was built by the Oregon Department of Transportation. The original dedication program noted that the 1922 West Linn–Oregon City bridge was "the most beautiful bridge in America." A formal opening and dedication took place on December 28, 1922, complete with a queen contest, parade, and public wedding.

In 1889, Willamette Falls Electric Company, also built on the falls, produced the first long-distance transmission of electricity for commercial purposes in the United States from Station A in Oregon City, illuminating more than 50 streetlights in downtown Portland, 13 miles to the north. Station B, now called the T. W. Sullivan Plant, was opened in West Linn in 1895 and remains to this day.

The West Linn Paper Mill opened as Willamette Pulp and Paper in 1889, merging with Crown Columbia in 1914 to become Crown-Willamette Paper Company. In 1928, the company merged with Zellerbach Paper Company of San Francisco and was known as Crown-Zellerbach. In 1947, Crown-Zellerbach pioneered the coated paper process. In 1986, James River Corporation acquired the company, and in 1990, it became Simpson Paper Company. It has been West Linn Paper Company since 1997.

Willamette Falls Electric Line began in 1891, eventually connecting the area that would later become West Linn, including Bolton (at the north), West Oregon City (or Sunset, in the middle), and Willamette.

On August 15, 1913, the city of West Linn—encompassing Sunset City, West Oregon City, Bolton, Willamette Heights, the west-side addition to Oregon City, Windsor, and Weslynn—was incorporated, allowing needed services without annexation to Oregon City. A contest to name the city christened the town Millsburg, but residents resisted, and instead the city has the name known today. The town of Willamette, which had been incorporated as a city in 1908, was annexed to West Linn in 1916.

West Linn's population growth has been steady, moving beyond a mill town. In 1920, the population was 1,628, and the 1960 census counted the population at 2,923; by 1970, West Linn included more than 7,000. In 1990, 18,000 people counted West Linn home, while today, the population sits at over 24,000.

With its emphasis on community, schools, parks, and family, West Linn is a sought-after community in which to live. Many who grow up here return to raise their own families. Generations of families have continuously called West Linn home. The city, which boasts one of the highest per capita income levels in Oregon, made *Money* magazine's 2005 Top 100 List of Best Places to Live and has gained Tree City U.S.A. status yearly since 1996. Indeed, West Linn is the "City of Hills, Trees and Rivers," and the place where the largest iron meteorite ever unearthed in the United States was discovered.

One

IN THE BEGINNING
WHAT'S IN A NAME

Robert Moore arrived on the west side of the Willamette River at the falls in 1840, establishing what became Linn City, and Hugh Burns platted Multnomah City to the north; Gabriel, Albert and George Walling staked out land still north of Burns; while James and Nancy Athey arrived in Linn City in 1843 and, in 1850, claimed land in the Stafford area, as did brothers Benjamin and Matthew Athey. Many others, including Moore's son, James M. Moore, Marshall K. Perrin, Ambrose and Joseph Fields, and Samuel and Rachael Miller, claimed land under the 1850 Donation Land Claim Act.

In 1913, a group of mill professionals and managers who lived in the Bolton and Sunset areas formed the West Side Improvement Club to discuss incorporating to gain tax revenue from the mills and hydroelectric plant as well as tracts clustered near the west end of the bridge. They voted in 1913 to incorporate as a city within the state of Oregon and included the mills as well as Sunset City, West Oregon City, Bolton, Willamette Heights, the west-side addition to Oregon City, Windsor, and Weslynn.

Willamette Falls (later shortened to Willamette), which incorporated in 1908 as a city, wanted to annex those properties as well and scheduled their own vote but lost twice. They claimed the vote was rigged.

Meanwhile, Bertram Telfair "Bert" McBain, a representative of the Crown Columbia Paper Company, offered $5 for the best name for the proposed newly incorporated area. Suggestions were as follows: Moonlight, Twilight, Millsboro, Millsburg, Willamette Links, Wiloreton, Belvidere, Fallsview, Harriman, Birmingham, Dale, Firland, Fir City, Hoodview, Hillmount, Mills Falls, Millbrook, Lee McBain City, McBainville, Oregon View, Oakwood, Richmond, Rosedale, Rose City, Rosecliff, Sunset City, Sunnyside, Strahorn, Westlynn, and Woodrow. The three judges, J. V. Campbell, Hon. G. B. Dimick, and the Reverend C. W. Robinson, voted against all of the names, but then settled on Millsburg. No one was satisfied with the name except its author, J. Nichols. After a week, it was announced in the June 28, 1913, Oregon City *Morning Enterprise* newspaper that Millsburg would be renamed West Linn in memory of the old pioneer town of Linn City, which once stood on its site.

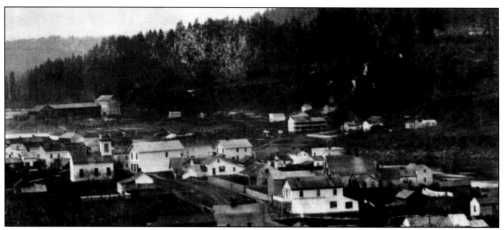

PHOTOGRAPHER LORENZO LORAIN'S VIEW OF LINN CITY. Lt. Lorenzo Lorain captured this image of early Linn City in 1857. Robert Moore, who founded Linn City, built mills, warehouses, and a breakwater and portage basin. To the right of center is the Linn City Hotel. Lorain was one of the first to photograph the region. In April 1861, a fire then a flood destroyed Linn City. (Courtesy Oregon Historical Society.)

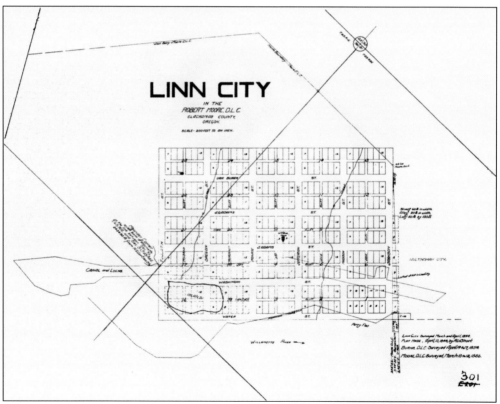

PLAT MAP OF LINN CITY. Linn City was surveyed in March and April 1844, and the plat was created April 10, 1844. Moore's 1850s Donation Land Claim Act gave him 250 acres near the current West Linn–Oregon City bridge to start the Willamette area. (Courtesy *Just Yesterday: A Brief Story of West Linn.*)

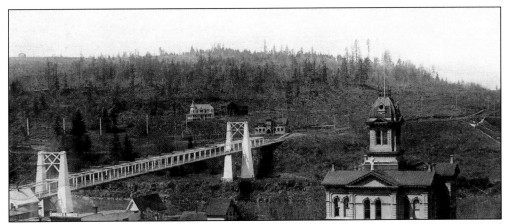

WEST LINN'S FIRST MAYOR'S HOME. The 1888 suspension bridge connected Oregon City and what would become West Linn. The white Lewthwaite-Moffat House is in the distance. The Lewthwaites were paper mill managers, and John B. Lewthwaite was West Linn's first mayor when the city incorporated as West Linn in 1913. Currently, the law offices of Abbott and Munns are located in the Lewthwaite-Moffat House. (Courtesy Oregon Historical Society.)

HUGH BURNS SETTLES NORTH OF LINN CITY. Hugh Burns, a native of Ireland, arrived on the west side of the falls in 1842, platting Multnomah City north of Linn City. He operated a ferry service between Multnomah City and Oregon City. By 1850, his brothers, Lawrence and Daniel, also claimed land nearby, and all three married women named Mary. The library sits on Burns Street. (Courtesy Oregon Historical Society.)

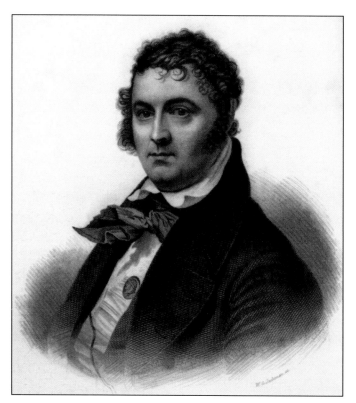

CITY'S NAMESAKE. Born in 1796, Lewis Fields Linn was orphaned at age 11 and was cared for by his half-brother. As a doctor in the Missouri Territory, he helped stop cholera. Linn became a senator in Missouri and a free-state advocate. Robert Moore knew Linn from Missouri and renamed his Robin's Nest Linn City in honor of Linn, who died in 1843. (Courtesy John Klatt.)

ROBINWOOD AND MARYLHURST AREAS. In the later part of the 1840s, Gabriel Walling staked out land in what is the current Robinwood area of West Linn, and his son Albert G. Walling claimed land in the area as well, eventually becoming a publisher. Albert's brother George settled on property that became the Marylhurst area. (Courtesy John Klatt.)

JAMES AND NANCY ATHEY. James M. and Nancy Athey arrived in Linn City in 1843 with the first large wagon train to journey on the Oregon Trail. James was a cabinetmaker. By 1860, they had nine children. Under the 1850 Donation Land Claim Act, James and Nancy purchased land in the Stafford area, and they were joined by his brothers, Benjamin and Matthew. (Courtesy Oregon Historical Society.)

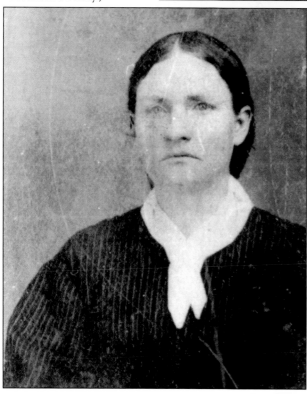

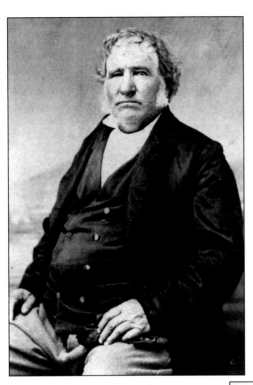

SAMUEL MILLER. Miller, his wife, Rachael J., and their five children crossed the Oregon Trail in 1850 and arrived at Willamette Falls, claiming 633 acres in 1865 as part of the Donation Land Claim Act. In addition to working in the Oregon City flour mill with Dr. John McLoughlin, Samuel Miller farmed the land, and his son Thomas established himself in the area as well. (Courtesy Oregon Historical Society.)

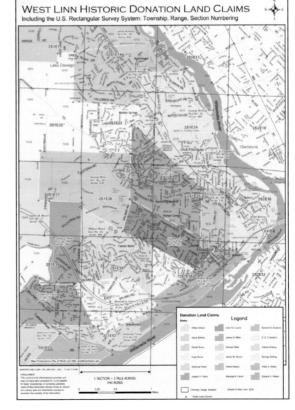

DONATION LAND CLAIMS. Here are the various Donation Land Claims areas, placed into a modern context. Note the names Fields, Moore, Lewis, Burns, Walling, Thompkins, Miller, and Weiss, whom Pete's Mountain was named after. (Courtesy City of West Linn.)

Two

ON THE

INTERNATIONAL MAP
THE WILLAMETTE METEORITE

In 1902, Ellis G. Hughes, a farmer from Wales, and Bill Dale, a prospector from Baker, were coming home from cutting firewood for Willamette School when they discovered a large, partially buried rock on land near Hughes's home on the current Grapevine Road. After hearing a ringing sound emitting when the stone was struck with a white rock, the two men realized that what they discovered was a large iron meteorite. They discussed ways to raise revenue to purchase the land from Oregon Iron and Steel Company, which owned the property that the meteorite was found on. Dale left the area to sell land in eastern Oregon to purchase the land, but he did not return right away. Ellis Hughes offered to purchase the land from Oregon Iron and Steel, but when they refused, Hughes decided to secretively move the 15.5-ton mass onto his own land three quarters of a mile away. He fashioned a simple windlass and anchored it with logging chain, then built a crude truck of logs with wooden wheels. It took Hughes, his 15-year-old stepson, Edward, his wife, Phoebe, and friends, along with his horse, three months to move the mass onto Hughes's own land.

Hughes built a shed around the meteorite and charged people 25¢ to see it. Sightseers came by electric streetcar then walked 2 miles to view the exhibit, which is the largest iron meteorite discovered in the United States and the sixth largest in the world. Visitors included lawyers for Oregon Iron and Steel, which filed suit on November 27, 1903, and won. Ellis Hughes appealed to the Oregon Supreme Court, and he lost again.

Oregon Iron and Steel exhibited the 15.5-ton mass at the 1905 Lewis and Clark Centennial Exposition, which drew over two million visitors to the 400 acres of what is now an industrial area in Northwest Portland. Exhibitors for the almost-five-month fair were from 21 countries and 16 states. Later Sarah Dodge of New York purchased the meteorite for $26,000. She then donated it to New York's American Museum of Natural History. The rare metallic iron Willamette Meteorite is an important scientific specimen now preserved in the museum's Department of Earth and Planetary Sciences. It is thought to have originated from the asteroid belt between Mars and Jupiter and was carried by the Missoula Floods near the end of the last ice age, some believe about 12,000 to 15,000 years ago.

In 1990, third-grade school children from Lake Oswego's Forest Hills Elementary launched a campaign to get the Willamette Meteorite returned, which become a national story. Native Americans claimed ownership of what they called the *tomonowos*—visitor from the moon—and reached an agreement with the museum to allow yearly private ceremonies around the meteorite.

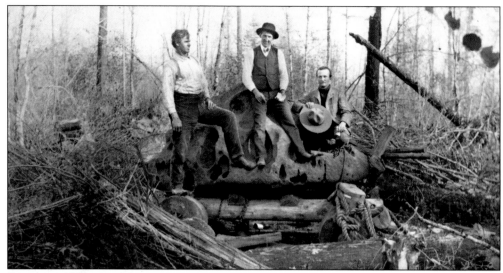

STRUGGLE BETWEEN MAN AND METEORITE. In August 1903, from left to right, Ellis Hughes, unidentified, and Frenchie Regis stand on the 15.5-ton Willamette Meteorite, which is on the cart that Hughes built to move it. Hughes, who owned a farm near Willamette, Oregon, secretively moved the mass onto his own land three quarters of a mile away. It took him three months. (Courtesy Oregon Historical Society.)

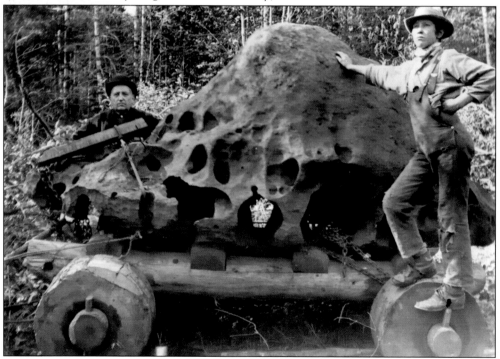

BILL DALE AND ELLIS HUGHES'S SON. Edward Hughes (right), the 15-year-old step-son and nephew of Ellis Hughes, poses with Bill Dale, behind the Willamette Meteorite. Ellis Hughes married Phoebe after her husband (the brother of Ellis) died, which is how Edward Hughes was both the step-son and nephew of Ellis, explains Bill Hughes, the grandson of Ellis Hughes. (Courtesy Oregon Historical Society.)

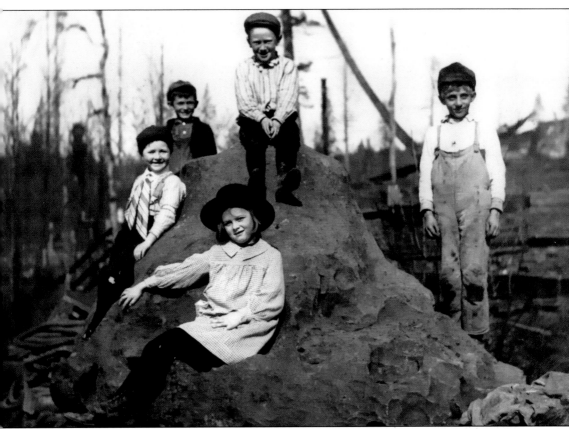

THE GIRL IN THE HAT. Fred Leavens snapped this 1905 photograph of his niece Ruth Leavens (wearing a hat) along with four unidentified boys on the Willamette Meteorite. The story of the Willamette Meteorite begins in early solar system history, when it is believed that an orbiting planet was shattered into fragments. One of these fragments was the Willamette Meteorite, which is said to have landed in Canada. As the Ice Age drew to a close, some believe about 12,000 to 15,000 years ago, massive sheets of ice began to melt, causing cataclysmic floods, which sent huge chunks of ice containing rocks and boulders—and the Willamette Meteorite—toward the Pacific Ocean. The floods swept through Oregon City and West Linn, and as the floods receded, icebergs were stranded, leaving their loads behind. The Willamette Meteorite was on an iceberg that ended its journey in the area now known as West Linn. New York–born scientist Henry Augustus Ward traveled four days by railroad to study the 15.5-ton meteorite, which had been reported on in national newspapers, and he presented his findings to the Rochester Academy of Science. He died in 1906. Ward described the area as a "wild" region "covered by a primeval forest of pines and birch, little visited and largely inaccessible." (Courtesy Oregon Historical Society.)

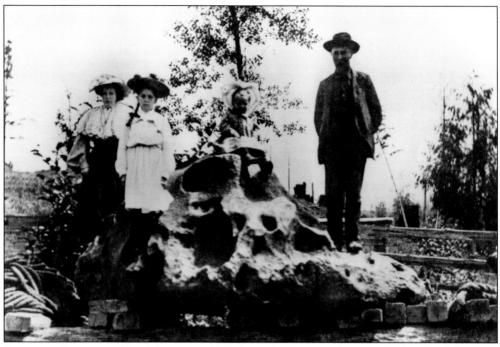

JOHNSON CHILDREN. Tom Johnson and his three children stand on the Willamette Meteorite in 1905 near the Johnson farm, which has a street named after it. From left to right are Nellie Johnson Giles, Bessie Johnson Colson, Harold Johnson, and Tom Johnson. Tom Johnson was deputized to guard the meteorite, according to Dick Pugh, a meteorite scientist. (Courtesy Clackamas Historical Society.)

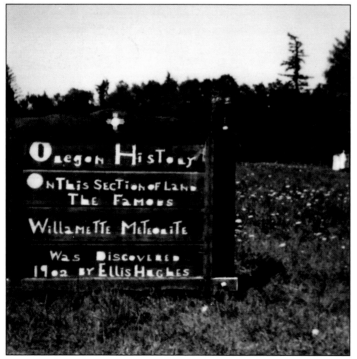

OREGON HISTORY. The Willamette Meteorite commemorative wooden sign was on display on what is now Johnson Road, where Ellis Hughes moved the meteorite. People traveled for miles to see the "15.5-ton mass from heaven." Discoverer Ellis Hughes charged the curious 25¢ per view. One of his visitors was an attorney for Oregon Iron and Steel, who sued to have the meteorite returned to their land. They ultimately won in the Oregon Supreme Court. (Courtesy Clackamas County Historical Society.)

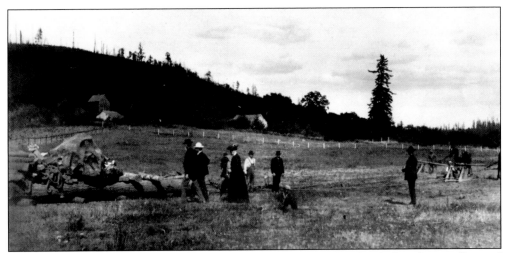

MOVING THE METEORITE. The Willamette Meteorite was moved on log skids with a windlass and stout horses toward the Johnson Road area at the mouth of the Tualatin River. It was barged through the Willamette Falls Locks and down the Willamette River toward Portland to be featured at the 1905 Lewis and Clark Exposition. This photograph was taken by Fred Leavens near the current Interstate 205 and Nineteenth Street in Willamette. (Courtesy Canby Historical Society.)

NEW YORK, NEW YORK. The Willamette Meteorite was donated to the American Museum of Natural History by Sarah Dodge of New York, who purchased the 15.5-ton mass for $26,000 after viewing it at the Lewis and Clark Exposition, Portland's World's Fair. The Willamette Meteorite is currently featured in the Hayden Planetarium at the museum. (Courtesy Alan and Elsie Lewis.)

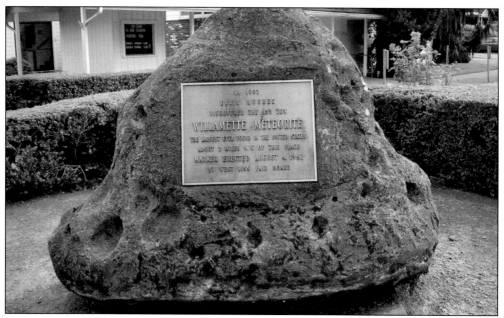

SEEING DOUBLE. The Willamette Meteorite replica was originally located outside the Willamette Fire Station in West Linn in the 1950s. When the building was remodeled, if it weren't for Ben Fritchie Jr., who ran Willamette Builders Supply from the 1940s to the 1980s, it would have been thrown out, Fritchie says. He helped get the Willamette Meteorite replica placed permanently in front of Willamette United Methodist Church, where it was erected August 4, 1962. There is also a Willamette Meteorite replica on the University of Oregon campus in Eugene. (Courtesy author's collection.)

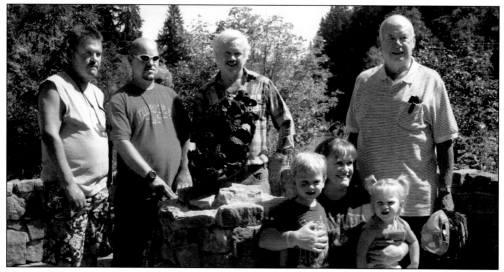

WORLD METEORITE DAY. On August 23, 2008, the World Meteorite Day was held at Fields Park in the Willamette area of West Linn. Pictured in front of the newly built Willamette Meteorite replica are descendants of Ellis Hughes, who discovered the Willamette Meteorite with Bill Dale in 1902. From left to right are (first row) Hunter, Michelle, and Kallan Gray; (second row) Scott Hughes, Ryan Hughes, Bob Huysman, and Bill Hughes, the grandson of Ellis Hughes. (Courtesy author's collection.)

Three

Rivers Run around Us
The Willamette Falls and Industry

The Willamette River has been a focal point for life in Oregon for centuries. People have savored the river for its power, transportation, and entertainment. The local Native Americans coined the term *tum-tum*—heartbeat—to refer to the Willamette Falls. They, and then the early pioneers, viewed the falls as the heart of life and trade.

The Willamette Falls, with a crest length of more than a quarter of a mile and a width of over 1,500 feet, separate West Linn and Oregon City and, based upon water volume, is the largest waterfall in the Pacific Northwest, the third largest in United States, and the 18th largest in the world.

For years, the falls were a prime location for Native Americans to catch salmon, and as settlers arrived, the falls became the force that powered the industry that grew up around them. The paper company and the electric plant were built at the falls to make use of the waterpower.

Before railroads and adequate roads, riverboats were the main transportation for cargo and passengers over long distances. The issue on the Willamette River was how to get around the falls. Hoisting entire vessels and cargo over the falls as well as carrying small boats and cargo around the falls were early solutions.

The idea of a full-length canal and locks took place in 1868. The state legislature pitched in $200,000 in 1870, and by the end of 1872, the Willamette Falls Locks and Canal had been completed at a total cost of $600,000. On New Year's Day 1873, the steamer *Maria Wilkins* was the first to navigate through the new locks. The Willamette Falls Locks and Canal, listed on the National Register of Historic Places, is the oldest continuously operating, multiple-lift navigation locks and canal in the United States. The locks, the paper mill, and the electric plant share space as well as the natural resources available.

Mention the word "river" in West Linn, and the Bernert, Tuor, and Bietschek families come to mind. The Bernerts started running the first power tugboats in the Willamette area in 1907, and a boat landing there is named after the Bernert brothers. Family members still live in the area. Besides the Willamette River, the Tualatin River surrounds West Linn, distinguishing West Linn as the City of Rivers.

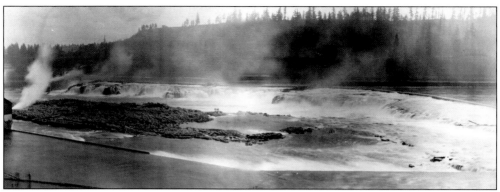

Pacific Northwest's Largest Waterfall. The Willamette River Falls, shown between 1873 and 1888, are a 42-foot horseshoe-shaped falls at West Linn and Oregon City. It is the largest waterfall in the Northwest, with a crest length of 1,700 feet, and the third largest in United States. Note the men standing out in the edge of the water. (Courtesy U.S. Army Corps of Engineers, Portland.)

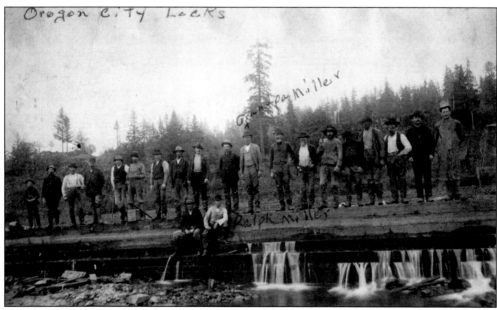

Crew Built Locks. Before railroads and adequate roads, riverboats were the main transportation for cargo and passengers over long distances. The issue on the Willamette River was getting around Willamette Falls. Early solutions included carrying small boats and cargo around the falls or hoisting entire vessels and cargo over the falls. A canal and locks were the better answer. (Courtesy John Klatt.)

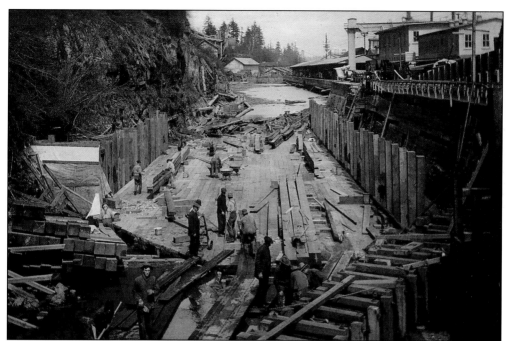

BUILDING THE LOCKS. Construction of the multi-lift navigation system cost $600,000, including a $200,000 grant from the State of Oregon. Begun in 1870, the Willamette Falls Locks and Canal, which included four lock chambers, a canal basin, and a guard lock, took two years to complete. Each lock is 40 feet wide and 210 feet long. (Courtesy U.S. Army Corps of Engineers., Portland.)

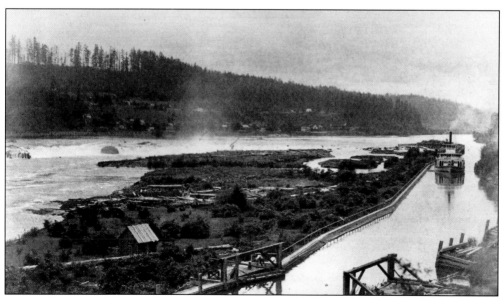

NEWLY COMPLETED LOCKS. Ownership of the canal and locks, which is the oldest continuously operating, multiple-lift navigation canal in the United States, changed hands several times before the U.S. Army Corps of Engineers purchased it from Portland Railway Light and Power Company in 1915 for $375,000. In 1974, it was placed on the National Register of Historic Places. (Courtesy U.S. Army Corps of Engineers, Portland.)

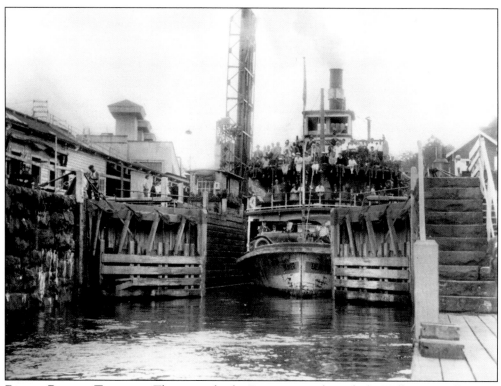

BEAVER PASSING THROUGH. The stern-wheeler *Beaver* passes through the Willamette Falls Locks and Canal. Notice the Model T Ford on board in the bow of the ferry around 1900. (Courtesy Oregon Historical Society.)

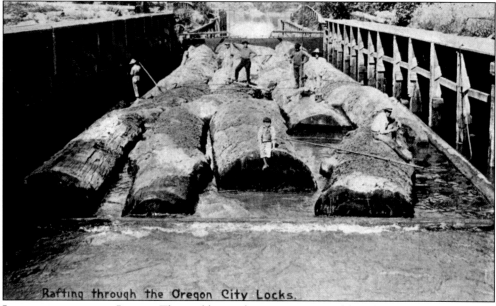

Rafting through the Oregon City Locks.

LOGS THROUGH THE LOCKS. These old-growth trees were most likely headed off to a sawmill downriver. Notice the younger person up front, enjoying the ride through the locks on logs. (Courtesy John Klatt.)

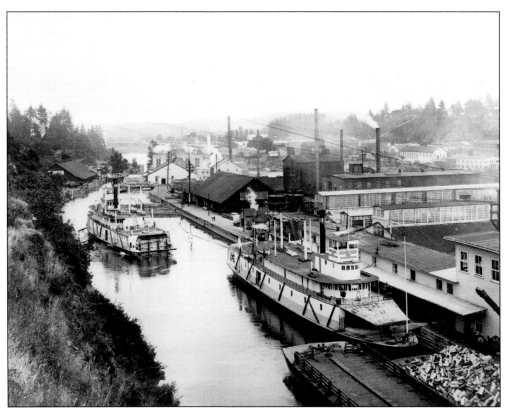

N. R. LANG THROUGH THE LOCKS. The stern-wheeler *N. R. Lang* moved through the Willamette Falls Locks and Canal after 1888. The suspension bridge—built in 1888 and connecting Oregon City and what would become West Linn—is seen in the distance. (Oregon Historical Society.)

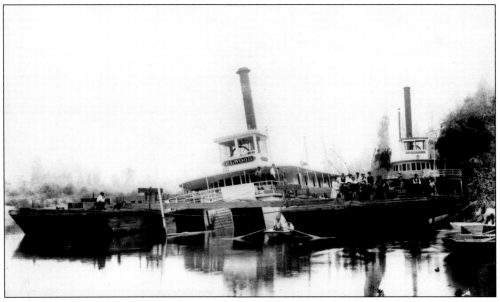

ELWOOD STEAMER SINKS. At the upper end of the Willamette Falls Locks and Canal, the steamer *Elwood* sank in the early 1900s. The *Modoc* assists. (Courtesy Clackamas Historical Society.)

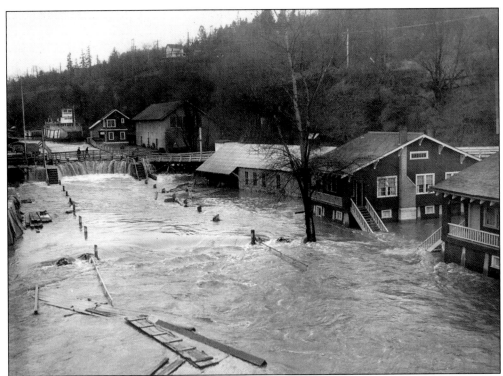

1948 FLOOD. The Willamette Falls Locks and Canal and parts of the paper mill are covered during the 1948 flood. The two buildings in the lower right are former locks operators' living quarters. The fourth building from the right is a West Linn Paper Company warehouse. The old locks master's station—now the U.S. Army Corps of Engineers Museum—is the farthest building on the right. (Courtesy the U.S. Army Corps of Engineers, Portland.)

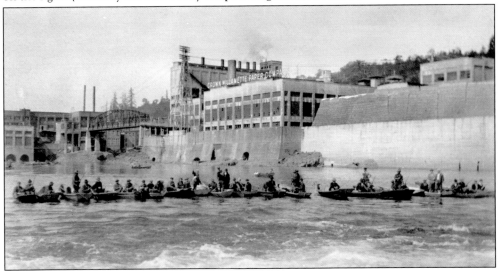

SHARING SPACE. People have come for centuries to fish at the falls, and they continue to as industry has grown around it. Notice the Crown-Willamette Paper Company sign in the upper middle, which was the name of the company on the west side of the river between 1914 and 1928. (Courtesy John Klatt.)

BUSINESSES COINCIDE AT THE FALLS. The locks, the paper mill, and the electric plant were all built at the Willamette Falls to make use of its power. The four Willamette Falls lock chambers are in the middle, and the West Linn Paper Company administration building sits just behind the parking lot to the right. Buildings to left of the lock chambers are the paper mill's coating plant, paper machines, and finishing and wrapping areas. (Courtesy Alan and Elsie Lewis.)

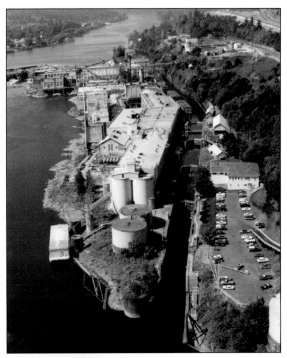

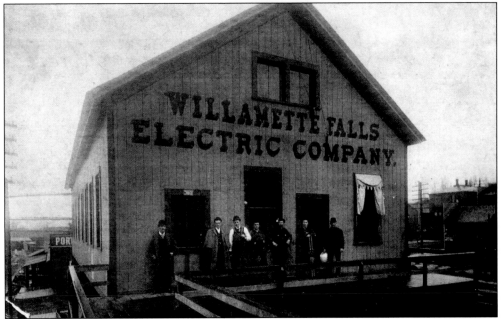

WILLAMETTE FALLS ELECTRIC COMPANY. On June 3, 1889, the Willamette Falls Electric Company —now Portland General Electric—transmitted electricity 13 miles from its generating plant Station A at the falls to Portland, which was the first instance of long-distance transmission of electrical energy for commercial purposes in the United States. In 1895, Willamette Falls Electric opened Station B (T. W. Sullivan Plant), which still operates in West Linn today, on the west side of the Willamette River. Station A in Oregon City was closed in 1897. (Courtesy Clackamas County Historical Society.)

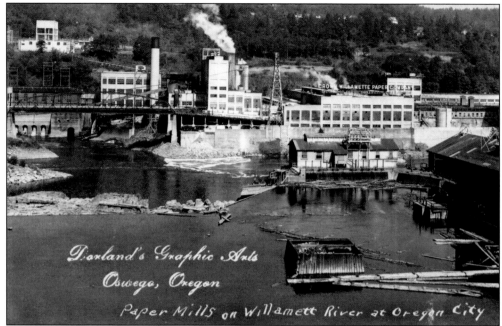

WEST LINN PAPER MILL. The paper mill in West Linn near the Willamette Falls on the Willamette River has been producing paper goods for almost 120 years. It opened as Willamette Pulp and Paper in 1889 and merged with Crown-Columbia in 1914, as seen in the photograph. Going through various mergers, it has been West Linn Paper Company since 1997 and employs about 250 people. West Linn Paper Company produces coated paper for publishing, catalogs, direct mail pieces, and magazines. (Courtesy John Klatt.)

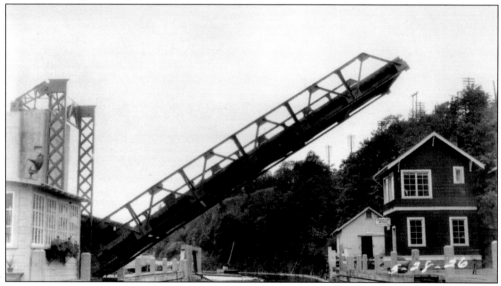

DRAWBRIDGE TO ISLAND. The West Linn Paper Company's mill is on an island accessible only by the drawbridge. The mill's production facilities are on the left of the island; paper products are hauled across the bridge, then stored in a warehouse (not shown) to await being loaded on trucks for shipment to customers. On the right is the original locks master's house. (Courtesy West Linn Paper Company.)

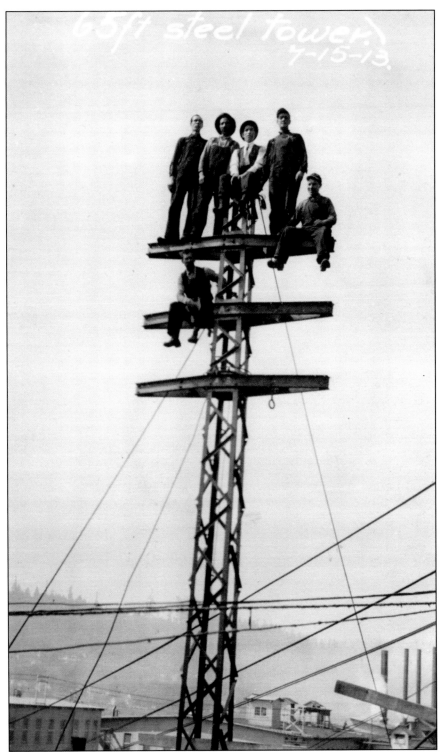

A GREAT VIEW. Men pose on the 65-foot steel tower at the Willamette Pulp and Paper Company in 1913. (Courtesy West Linn Paper Company.)

EDWARD GROSS, MILL WORKER. Edward Gross (left) worked at Crown-Willamette Paper Company beginning about 1915. He stayed on until he began his West Linn school bus service in 1927. Members of his family still live in West Linn. (Courtesy Esther Gross Betts.)

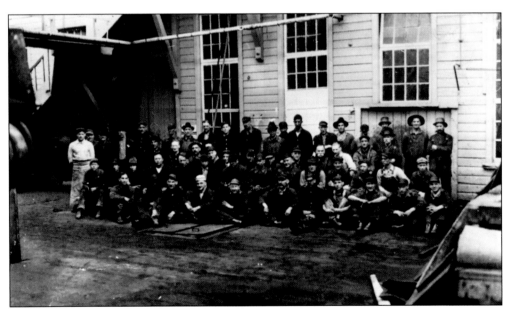

PAPER MILL GROUP SHOT. Workers at the paper mill (above) gather for a group photograph in the early 1900s. (Courtesy West Linn Paper Company.)

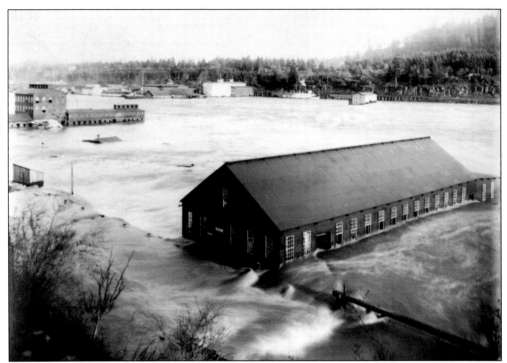

FLOOD OF 1890. The flood of 1890 highlights the power of the river. In the distance is the flooded original Station A of the Willamette Falls Electric Company. (Courtesy Clackamas County Historical Society.)

FATHER AND SON. Joseph H. Bernert (left), and his son James W. Bernert, age 10, sit on the stern of the *Grayling* on the upper Willamette River in 1936. Joseph's father, Joe, emigrated from Germany to Pete's Mountain in the 1860s and began logging in the river using a rowboat. Four generations of Bernerts have worked on the river, and members of the four generations have died on the river. (Courtesy Toni Dollowitch Bernert.)

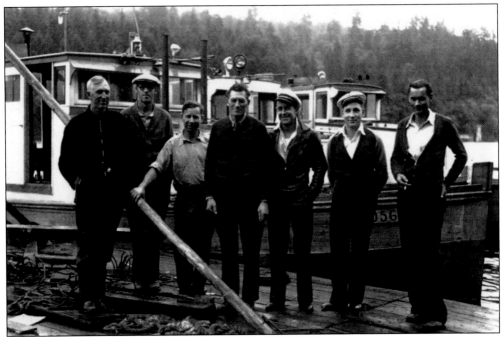

WEST LINN RIVER MEN. At the original boathouses of Joe Bernert Towing Company and Albert Bernert Towing Company, located by the lower part of the Willamette River just below Willamette Park, owners and operators of two Bernert brothers' businesses pose in front of the tugboats in 1930. From left to right are Joe Bernert, owner; Durward Criteser, operator; Frank Garlick, operator; Albert Bernert, owner; Charles "Smokey" Stoller, operator; Gail Merwin, operator; and Paul Wallace, operator. (Courtesy Toni Dollowitch Bernert.)

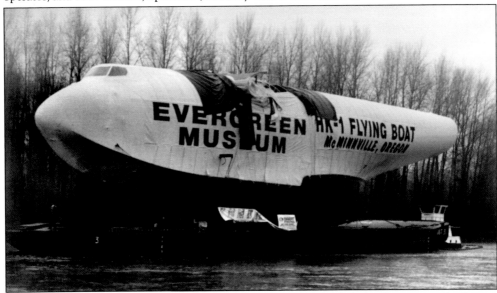

BERNERTS HAUL SPRUCE GOOSE. Members of the Bernert family helped transport the Spruce Goose to the falls in 1992. Known as the Hughes HK-1 flying boat, it was conceived during World War II but not completed until after the war. Flown only once, on November 2, 1947, by Howard Hughes, the Spruce Goose remains the largest plane ever built. (Courtesy Tom Bernert.)

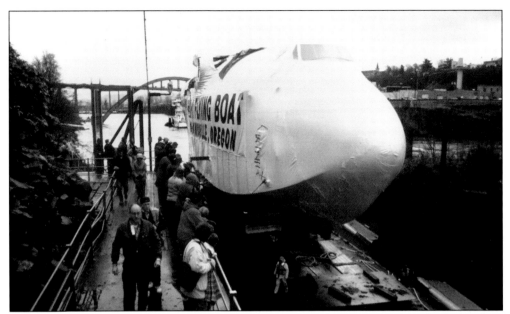

HOWARD HUGHES HK-1 FLYING BOAT THROUGH FALLS. The Spruce Goose, also known as a flying boat, navigated the Willamette Falls Locks and Canal going upstream on December 18, 1992, to its current location, the Evergreen Aviation and Space Museum in McMinnville. Before this, thousands of people celebrated the Spruce Goose's arrival to Oregon with an official Spruce Goose Day on October 22, 1992, at Tom McCall Waterfront Park. (Courtesy U.S. Army Corps of Engineers, Portland.)

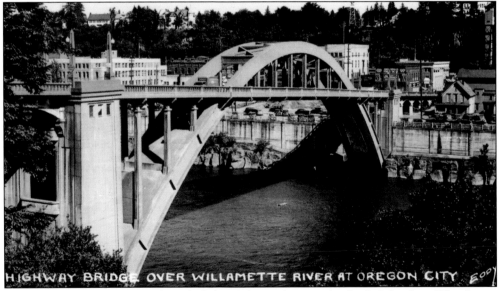

BRIDGE DETAILS. Resident Ed Lind's father, Ed, was foreman for the 740-foot-long West Linn–Oregon City bridge, built in 1922. The elder Lind worked for the old Guthrie Construction Company, which had the contract to build the replacement for the 1888 suspension bridge. The 1922 arched bridge was the first in a series designed by Conde B. McCullough, the state engineer who would, in his 25-year career with the Oregon Highway Department, have a hand in designing hundreds of bridges. (Courtesy Oregon Department of Transportation.)

Celebration of the

Formal Opening and Dedication

of the

Oregon City—[Oregon]—West Linn ^Pacific ^Highway Bridge

Across the Willamette River

"The Most Beautiful Bridge in America"

Completing the last major link in the Pacific Highway from Mexico to Canada

Thursday, December 28th, MCMXXII

Auspices: Oregon City Commercial Club and
West Linn Citizen Committee

CEREMONY CELEBRATES BRIDGE. On December 28, 1922, officials from both West Linn and Oregon City gathered for the formal opening and dedication of the Oregon City–West Linn bridge. Mayors were on hand, and a parade was held, as well as a banquet at West Linn Inn. A queen's contest was held as well as a public wedding. (Courtesy West Linn Historic Advisory Board.)

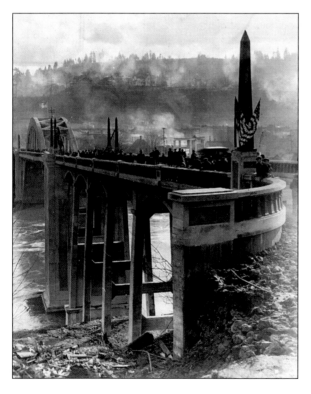

THE MOST BEAUTIFUL BRIDGE IN AMERICA. The 1922 Oregon City–West Linn bridge was constructed as a replacement for the 1888 suspension bridge that connected Oregon City to the west side of the river. The new bridge was coined "The Most Beautiful Bridge in America." Piers were designed to accommodate public restrooms, but vandalism over the years required they be closed in 1937. The bridge was placed on the National Register of Historic Places in 2005. (Courtesy Oregon Historical Society.)

Four

IT'S WHO YOU KNOW
SOME FAMOUS RESIDENTS
WITH WEST LINN TIES

West Linn is tied to many notable residents. Some grew up here then left to do great things, others moved here as adults, making a name for themselves, and another group moved here already with a name for themselves. They all have connections to West Linn.

David Hume Kennerly, a 1965 West Linn High School graduate, won the 1972 Pulitzer Prize for his photographs of the Vietnam War at the age of 25, and in 1974, at age 27, he became the youngest White House staff photographer under President Ford.

H. J. Belton Hamilton, who lives with his wife Midori in Robinwood, was Stanford University's first African American graduate in 1949 and Oregon's first African American assistant attorney general in the 1950s. His grandfather Smith Hamilton was a slave in Mississippi who was freed in 1863.

Doug Tunnell, whose father, Chester Tunnell, was superintendent of West Linn Schools from 1946 to 1976, graduated from West Linn in 1968 and became a CBS foreign news correspondent; and 1986 alumni Tess Vigeland now hosts National Public Radio's *Marketplace*.

Baseball standout Mitch Williams, a 1983 graduate, earned the nickname "Wild Thing" while playing for Chicago Cubs, and runner Dan Browne, a 1993 West Linn High graduate, competed on the 2004 U.S. Olympic Team. Brandon Ebel, a 1988 West Linn High graduate, founded the independent record label Tooth and Nail Records in 1993, signing artists such as Anberlin and Jeremy Camp.

Finger-style guitarist Mark Hanson became a 2005 Grammy winner, while commercial illustrator and pastel artist Marla Baggetta has had her work featured in international, national, and regional exhibitions. Former Portland Trailblazer basketball player Michael Harper, also a Royal Rosarian, still lives here, while Carol Geldaker is responsible for getting bicycle lanes in West Linn in the 1970s.

Pianist and composer John Nilsen takes his music nationally and to local schoolchildren. LaVerne Bagley was West Linn High School's first African American woman graduate in 1947, and her brother, Kernan H. Bagley, at age 28, was named Oregon's first African American deputy U.S. Marshal in 1963 and the first African American U.S. Marshal for Oregon in 1981, appointed by President Reagan. Senators Mark Hatfield and Bob Packwood nominated him. Renee Cleland became Oregon's first African American Miss Oregon in 1984.

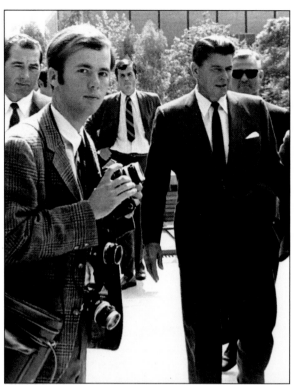

PHOTOGRAPHING REAGAN. Seen here is photographer David Kennerly (left), a 1965 West Linn High School graduate, with newly elected governor of California Ronald Reagan in 1968. "Ronald Reagan was the first major 'star' I photographed when I moved from Oregon to Los Angeles," Kennerly notes. Kennerly also photographed Reagan during Reagan's White House years. He has photographed every president since President Nixon. (Courtesy David Hume Kennerly.)

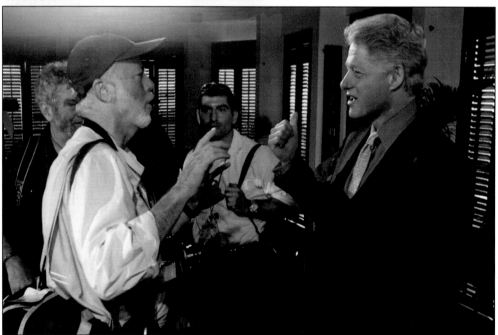

CLINTON AND KENNERLY. A 1965 West Linn High School graduate, David Kennerly (left) is talking with Pres. Bill Clinton in Saigon, Vietnam, in November 2000. Kennerly noted that Clinton went out of his way to talk to the photographers on the trip who had covered the Vietnam War, and Kennerly was one of them. (Courtesy David Hume Kennerly.)

PULITZER-PRIZE VIETNAM PHOTOGRAPHER. David Kennerly is carrying cameras in the Mekong Delta of Vietnam with South Vietnamese troops behind him in 1971. Kennerly, a 1965 West Linn High School graduate, was a staff photographer for United Press International covering the Vietnam War. At age 25, Kennerly won the 1972 Pulitzer Prize for his photographs of the Vietnam War. (Courtesy David Hume Kennerly.)

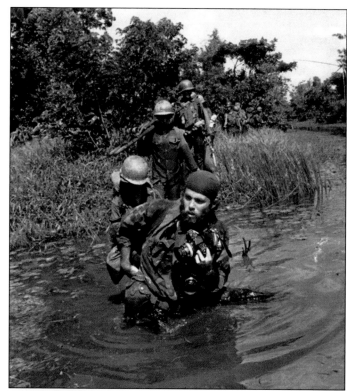

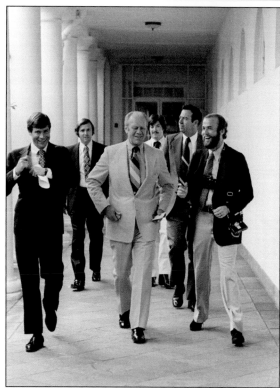

PRESIDENTIAL PHOTOGRAPHER. President Ford (center) and David Kennerly (right with cameras) walk along the colonnade from the west wing of the White House. On the day that President Ford assumed office as president in 1974, Kennerly, at the age of 27, was offered the position as Ford's White House photographer. He is the youngest White House photographer in U.S. history. (Courtesy David Hume Kennerly.)

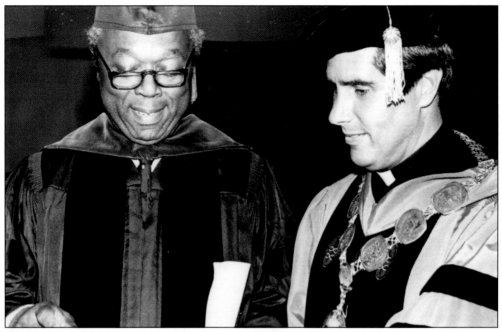

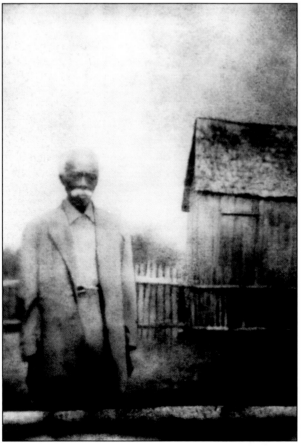

FIRST AFRICAN AMERICAN JUDGE. H. J. Belton Hamilton (above left) appears with the late University of Portland president Fr. Thomas Oddo before Hamilton's speech to the University of Portland graduating class of 1984. Hamilton, who lives with his wife Midori in the Robinwood neighborhood of West Linn, attended the University of Portland before transferring to Stanford University, where he was the first African American to graduate in 1949. He later became the first African American assistant attorney general for the state of Oregon under attorney general Robert Thornton in 1955. Hamilton was awarded the Purple Heart for his service during World War II. The photograph at left is of Smith Hamilton, age 80, when he was a slave in Mississippi. Smith Hamilton was the grandfather of H. J. Belton Hamilton. Smith Hamilton was freed by General Grant on May 8, 1863. (Courtesy H. J. Belton and Midori Hamilton.)

FOREIGN CORRESPONDENT BECOMES WINEMAKER. Posing on an Ethiopian army tank (an old Soviet T-54 battle tank) is West Linn High 1967 graduate Doug Tunnell (center) while covering the Eritrean guerilla war of secession from Ethiopia for CBS News in 1988. Tunnell spent 18 years as a CBS foreign correspondent before establishing Brick House Vineyards in Newberg. His father, Chester, was superintendant of West Linn schools from 1943 to 1976. (Courtesy Doug Tunnell.)

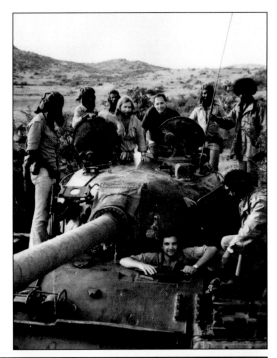

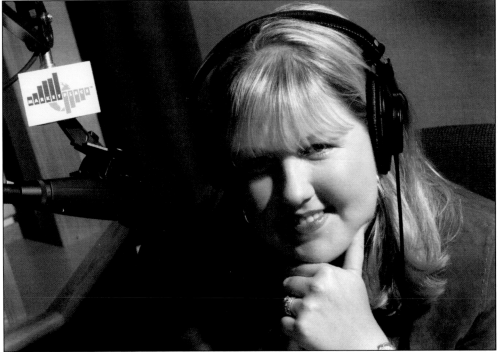

NATIONAL PUBLIC RADIO HOST. Tess Vigeland, a 1986 West Linn High graduate, has been a National Public Radio host for various *Marketplace* programs since 2001. She credits her English teacher, Bob Hamm, for encouraging her to write for the school newspaper. "One of the best teachers I ever had. I enjoyed the paper so much that I applied to Journalism School at Medill and got in," said Vigeland. (Courtesy Tess Vigeland.)

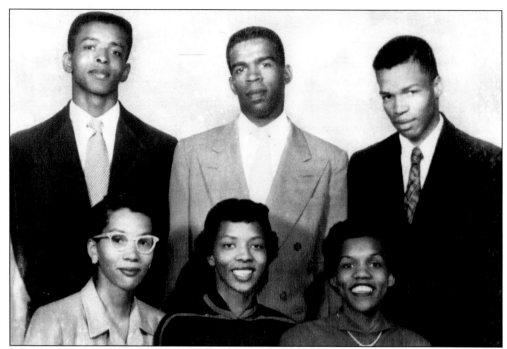

DOUBLE FIRSTS IN BAGLEY FAMILY. Donald Sr. and Bessie Bagley bought property on Pete's Mountain in 1939. Their children are, from left to right (first row) LaVerne, DonaClair, and Darlene; (second row) Clyde, Donald Jr., and Kernan H.; sister Phyllis died of leukemia in 1949. LaVerne was West Linn High's first African American woman graduate in 1947, and Kernan became the first African American U.S. Marshal for Oregon in 1981 under Pres. Ronald Reagan. (Courtesy Clyde and Rachelle Bagley.)

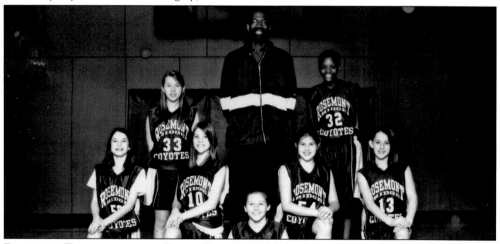

PORTLAND TRAILBLAZER AND ROYAL ROSARIAN. Michael Harper moved to West Linn in 1980 as an NBA Portland Trailblazer basketball player. He later played six years professionally in Europe before returning to West Linn. Harper is active in the community, including coaching basketball for his daughter Gaby's basketball team. He is a Royal Rosarian and was appointed to the State of Oregon Commission on Children and Families. Included in this photograph are, from left to right, (first row) unidentified; (second row) Hanna Cotter, Olivia Dunn, Amber Potz, and unidentified; (third row) unidentified, Michael Harper, and Gaby Harper. (Courtesy Michael Harper.)

"WILD THING." Mitch Williams, a 1982 West Linn High School graduate, earned the title "Wild Thing" while pitching for the Chicago Cubs. He also played for the Philadelphia Phillies beginning in 1991 and played in the World Series with them in 1993. He earned 192 career saves in his 11 seasons and a career high of 43 in 1993 for the Phillies. (Courtesy West Linn High School.)

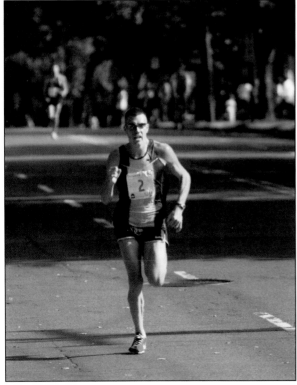

OLYMPIC ATHLETE. Dan Browne began running seriously as a junior at West Linn High School, graduating in 1993. Since then, he has competed on the international level, including making the 2004 U.S. Olympic Team for the 10,000 meters and the marathon held in Athens. He was 2002 U.S. marathon champion. (Courtesy Dan Browne.)

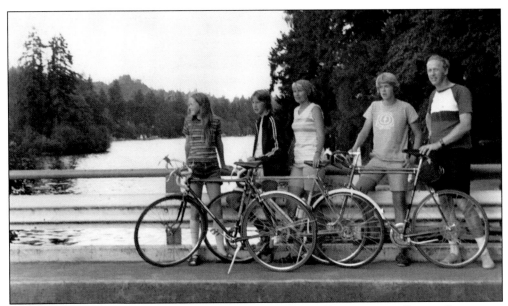

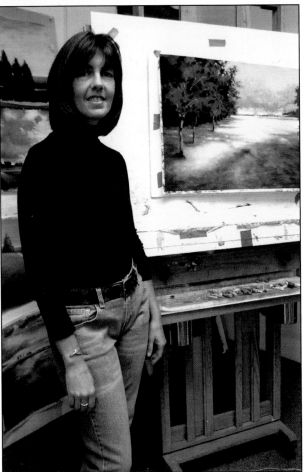

PATH-BLAZER CAROL. Because of Carol Geldaker (center with her family), West Linn has bicycle paths on Willamette Drive. "Back in the 70s, I was trying to walk [in the Robinwood neighborhood] with our buggy from our house to West Linn Lutheran Church, and it was a narrow part of the street with no shoulder, so you had to look quickly then run like mad," Geldaker shares. She appealed at the 1971 legislative session for bicycle paths and won. (Courtesy Carol Geldaker.)

WEST LINN PASTEL ARTIST. West Linn artist Marla Baggetta was a successful commercial illustrator, working for clients such as Walt Disney Productions, Harcourt Brace, McGraw-Hill, Nissan, and MGM Home Entertainment, before turning to landscape painting. She had a hand designing the West Linn sign featured as one enters West Linn off Interstate 205 in the Bolton area. Her husband, Mike Baggetta, is a rising abstract expressionist painter. (Courtesy Marla Baggetta.)

GRAMMY-WINNING GUITARIST.
West Linn finger-style guitarist
Mark Hanson holds the 2005
Grammy he won for the best
pop instrumental album, *Henry
Mancini-Pink Guitar.* He and
his wife, Greta Pedersen, also
a musician, traveled to the
Staples Center in Los Angeles,
California, for the ceremony.
(Courtesy Mark Hanson.)

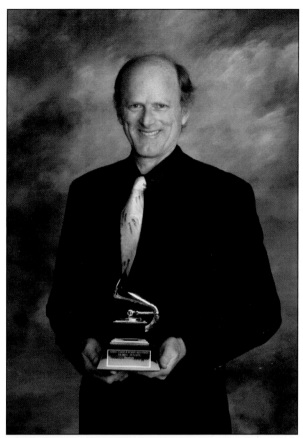

**TOOTH AND NAIL RECORDS
FOUNDER.** A 1988 West Linn
High graduate, Brandon Ebel
(second from left) founded Tooth
and Nail Records in 1993; he has
signed bands such as Anberlin,
Jeremy Camp, Blindside, the
Juliana Theory, and mewithoutYou.
Pictured with Brandon, from
left to right, are his mother,
Linda, sister, Heather, and father,
Dale, in 1987. Dale Ebel is the
founding pastor of Rolling Hills
Community Church in Tualatin.
(Courtesy Brandon Ebel.)

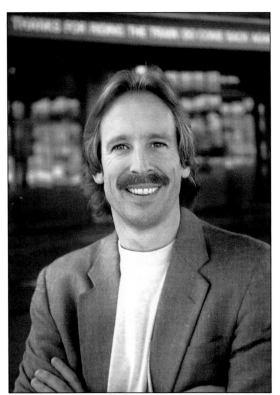

PIANIST AND COMPOSER. John Nilsen—guitarist, pianist, vocalist, composer, and coproducer—launched his musical career in the 1980s when he was invited by famed guitarist Guthrie Thomas to record on his Eagle Records label. Nilsen moved to West Linn in 1987 and has released 16 recordings. He has appeared with stars such as Kenny G, Jesse Colin Young, Alex De Grassi, and David Foster. He works often with students in schools. (Courtesy John Nilsen.)

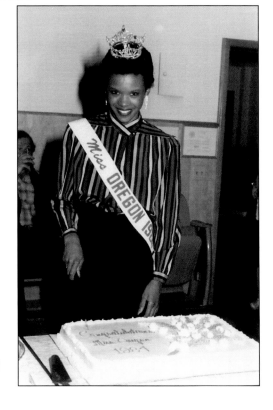

FIRST AFRICAN AMERICAN MISS OREGON. Renee Bagley Cleland was crowned the first African American Miss Oregon in 1984. Cleland, the daughter of Clyde and Rachelle Bagley, grew up in Pete's Mountain and now lives there with her family, down the street from her parents. Cleland is an accomplished vocalist. (Courtesy Rachelle Bagley.)

Five

GOVERNMENT SERVICES
CITY HALL, POLICE, FIRE, AND LIBRARY

The first mayor to take office in the newly incorporated city of West Linn in 1913 was John Brandow Lewthwaite, whose term ended in 1918. He was also a paper mill manager. Councilors who served alongside him for all or part of those five years were Nicholas Humphrys, Nicholas C. Michels, Leonard Pickens, Silas B. Shadle, Charles Shields, Oben Tonkin, Frank A. Hammerle, Adolph G. Volpp, Arnold Kohler, Ernest A. Leighton, John F. Clark, and William Edwards.

City hall members met in one room of the wooden Trolley Railroad Depot, located near the West Linn–Oregon City bridge, until it was torn down in 1935 by Bill Snidow of Willamette to make room for the new brick city hall. The new brick city hall was funded under a Depression-era Works Progress Administration project and housed many of the city's services for the 2,000 residents. It was built in 1936, and Mayor Frank A. Hammerle dedicated it as city hall that year.

The building housed a grocery store and several city offices over the years, including the West Linn Post Office. The West Linn Police Station moved there in 1956 and remains there today. The city's part-time public library, which was organized in 1939, was located there as well until it moved to the Bolton Fire Station annex in 1978. The new West Linn Public Library was completed in 1989.

West Linn's city hall moved into its current location on Salamo Road in 1999, while the brick 1936 city hall is now exclusively the city's police department.

Other city services include the fire department, which was organized in 1915 and had hose companies at city hall, Sunset, Willamette, and Bolton. Eventually the individual fire departments joined under the umbrella of the West Linn Fire Department, and in 1998, they began contracting out with Tualatin Valley Fire and Rescue Department, being permanently annexed after a public vote in 2004.

West Linn's senior community began organizing in 1993, meeting in various locations before raising funds to build a permanent home. In 2003, the West Linn Adult Community Center was completed and dedicated.

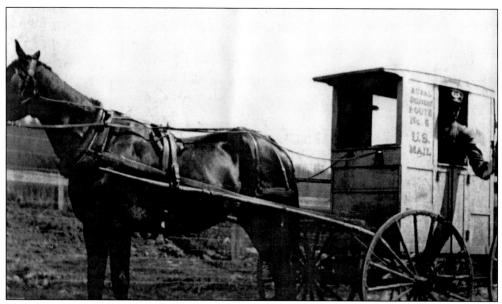

THE ORIGINAL MAILMAN. Willamette resident Charles Andrus delivered the mail in rural Willamette, U.S. Mail Route No. 5, from 1905 to 1938. His granddaughter Marjorie White still lives in Willamette. Residents gathered at the Ridder Store, which was at the southeast corner of Thirteenth Street and Willamette Falls Drive, to get their mail daily from Charley Ridder, who operated the Willamette Post Office from his store for more than 50 years before it joined the West Linn City Post Office. (Courtesy Marjorie White.)

MAYOR OF NEWLY INCORPORATED WILLAMETTE. On October 5, 1908, Willamette incorporated as a town in order to gain control of the water system which Portland General Electric Company owned at the time. James Downey was the mayor, and Harry T. Shipley, pictured here, became a councilor. The City of West Linn incorporated five years later, and Willamette joined it in 1916. H. T. Shipley was also a West Linn city councilor from 1919 to 1920. (Courtesy Dave and Judy Shipley.)

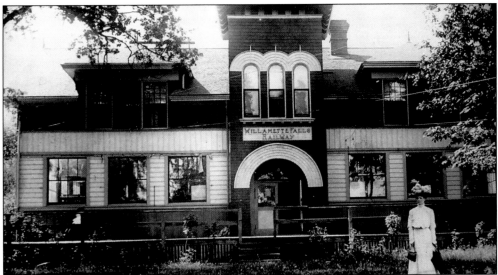

OLD CITY HALL/TROLLEY STATION. Seen here is the old wooden trolley station, which was located at 22825 Willamette Drive, just to the south of the Holly Grove neighborhood. City hall members met there until 1935, when the building was torn down to make room for the new city hall. The trolley was built by Portland General Electric to bring its employees over to the power plant. The trolley stopped running about 1934. (Courtesy Clackamas County Historical Society.)

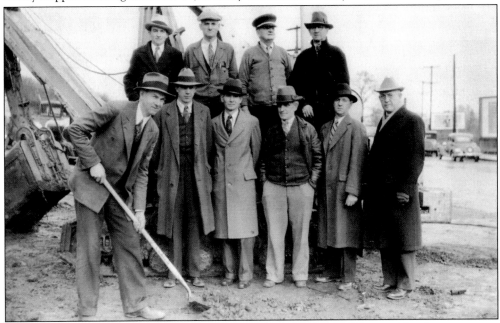

A NEW CITY HALL. The mayor and other officials gathered for the 1936 ground-breaking ceremony for the new city hall, which was constructed on the site of the former trolley station, next to the West Linn–Oregon City bridge. From left to right are the following: (front row) Mayor Frank Hammerle, councilor Aaron Thompson, councilor Burns Britton, councilor Karl Buse, councilor Mark Sturges, and city attorney J. Dean Butler; (back row) councilor Arthur Lindsley, former councilor Adolph Volpp, Chief Pete Winkel, and Charles Shields, who was mayor from 1923 to 1924. (Courtesy Clackamas Historical Society.)

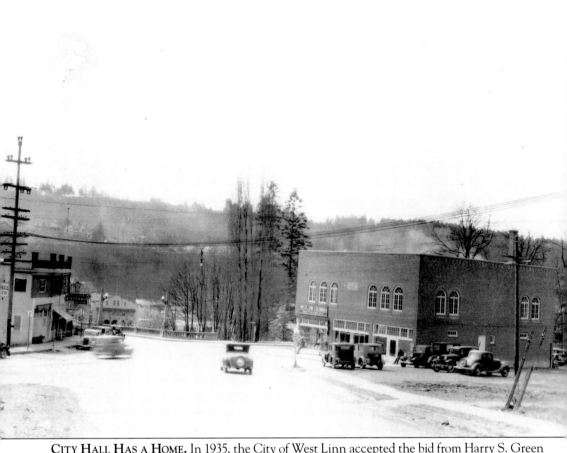

CITY HALL HAS A HOME. In 1935, the City of West Linn accepted the bid from Harry S. Green of Portland to construct a city hall building on the former site of the trolley station; the trolley had stopped running about 1934. City hall members had met in the trolley station until then. The new city hall building to be constructed was a Depression-era Works Progress Administration project and would cost $27,459. Claussen and Claussen, Inc., was the architect. Mayor Frank Hammerle dedicated the brick building as the new West Linn City Hall in 1936, when West Linn's population was about 2,000. In 1956, the police department began its tenure there. In 1999, city hall moved to Salamo Road, while the police station remains in the old city hall. Note the pool hall and grocery store signs on the left side of the street in the c. 1936 photograph; they refer to businesses that are gone now, though the buildings remain and are used as housing. The land that the (current) police station (and former city hall) sits on, except the footprint of the city hall/police building, is owned by the paper mill or Portland General Electric and always has been. The pictured brick (first) city hall building on the right has been home to various uses besides city hall and current police station since its 1936 construction. The West Linn Post Office was housed here, as well as the library, a grocery store, a meat market, and fire department equipment. (Courtesy George Matile and Michael R. Anderson.)

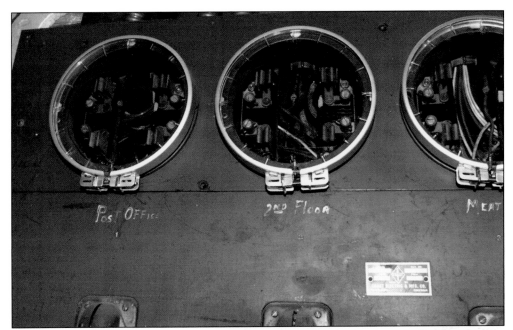

ORIGINAL METERS. Located on the way down to the dungeon of the 1936 brick city hall, which is the current police station, these original meters show the various uses of the brick building by the bridge. On the left is the post office meter, and on the right is the meat market. (Courtesy Michael R. Anderson.)

WEST LINN POLICE STATION. West Linn police moved into the brick city hall building in 1956. By 1999, all other city offices had been relocated, while the police department remains there. (Courtesy Michael R. Anderson.)

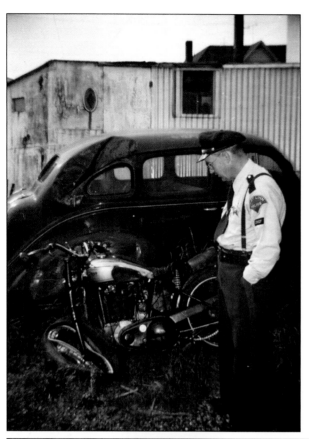

POLICE ON THE JOB. West Linn police chief Steve L. Goldade checks out the scene of an accident in West Linn. He was with the department for 20 years, serving 17 of them as chief. He retired in 1967. (Courtesy West Linn Police Department.)

FLOOD OF 1964. The Robinwood Fire Department came to the rescue in boats (below) during the 1964 flood that covered houses and streets on Nixon Road and other sections of the city. "The road was a river," shares Robinwood resident Mary Hill, whose basement was flooded 6 feet. (Courtesy Mary Hill.)

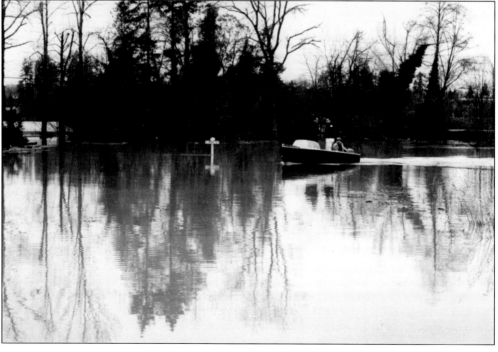

WILLAMETTE FIRE HALL. The West Linn Fire Department formed in 1915 and was made up of five hose companies located at Willamette, city hall, Bolton, and Sunset. The Willamette Station 59 was built in the 1950s and serves the historic Willamette District of West Linn, as well as Interstate 205 and the southern portion of the Willamette River. Station 59 houses nine full-time personnel. (Courtesy West Linn Historic Advisory Board.)

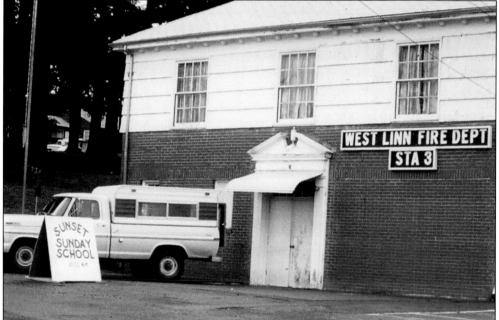

SUNSET FIRE HALL. Sunset Fire Hall is home to volunteer firefighters who respond to large incidents in support of career firefighters. The building is also often used by the city's parks and recreation department, civic groups, and neighbors. Boy Scout Troop 149 has met here for years. New Life Church (formerly West Linn Baptist) used the building for Sunday school, as the sign indicates, before they built their permanent home by West Linn High School. (Courtesy New Life Church.)

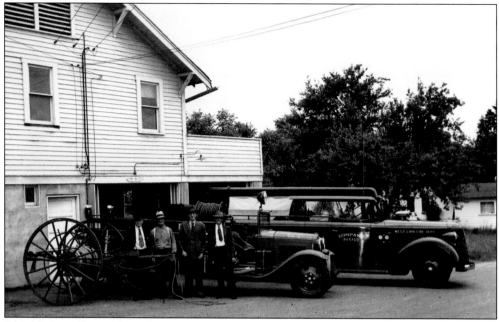

BUCK STREET BOYS. The Bolton fire station, also known as Station 58, was constructed in the late 1930s and was originally staffed with volunteers. The volunteer firefighters were dubbed the "Buck Street Boys," because most of the volunteers lived on Buck Street. The station's fire bell summoned the firefighters to the station for an alarm. (Courtesy Tualatin Valley Fire and Rescue.)

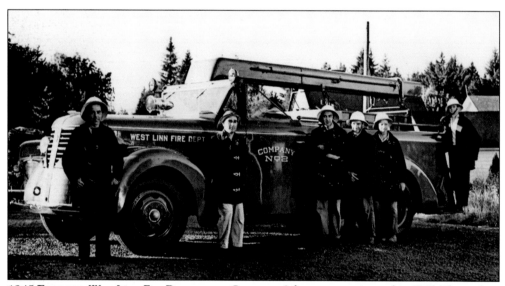

1945 FIREMEN. West Linn Fire Department Company 2 firemen are pictured in 1945. The earliest fire equipment consisted of a hand-pulled hose cart that was later replaced by two Ford Model A engines in the 1940s. The Model Ts were from the paper mill and were converted into fire engines in the late 1920s. In 1998, West Linn Fire Department contracted with Tualatin Valley Fire and Rescue to provide fire and emergency medical response. In 2004, citizens of West Linn voted to annex all West Linn Fire Departments permanently to Tualatin Valley Fire and Rescue. (Courtesy Tualatin Valley Fire and Rescue.)

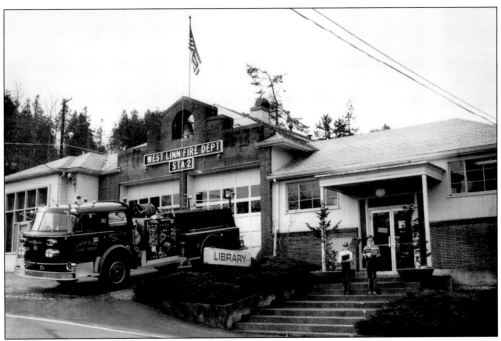

LIBRARY AND BOLTON FIRE HALL. When the new Bolton Fire Hall was built, the old one was moved across the street and became apartments. The library was housed here from 1978 until the completion of its new building in 1989 on Burns Street. The children in this 1982 photograph are Sarah and Paul Mauvais. (Courtesy Alan and Elsie Lewis.)

ROBINWOOD FIRE DEPARTMENT. Pictured at the old Robinwood Fire Station on Cedar Oak Drive are volunteer firefighters, from left to right, Vern Brinkley, Joe Hamel, Larry Woodrun, Chuck Hill, unidentified, Howard Reynolds, and fire chief Bill Bryant. (Courtesy Mary Hill.)

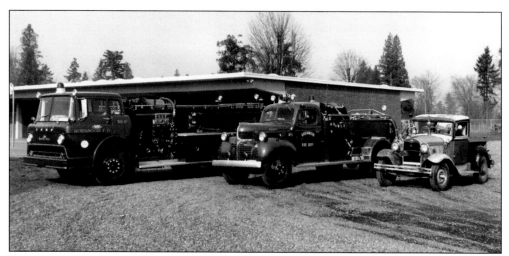

PARKED AT CEDAROAK PARK. Robinwood Fire Department trucks are parked at Cedaroak Park Primary School. The Cedaroak Fire Station is no longer a fire department facility, but is now a private ambulance company. American Medical Response uses the facility for emergency response in Clackamas County. The Robinwood Volunteer Fire Department dissolved in 1969, when it merged with West Linn Fire Department. (Courtesy Tualatin Valley Fire and Rescue.)

WATER BOARD AT ROBINWOOD. At the Robinwood Volunteer Fire Department water district annual party, members exchange gifts. Seated, from left to right, are Ruth Fetz, office assistant; Bert Smith, partially hidden on the left; Ed Lind; Betty Lind; and Gordan Peebles, facing the camera. Standing in the back and looking to the right side in this late-1950s photograph is Bill Bryant, the fire chief. (Courtesy Betty Lind.)

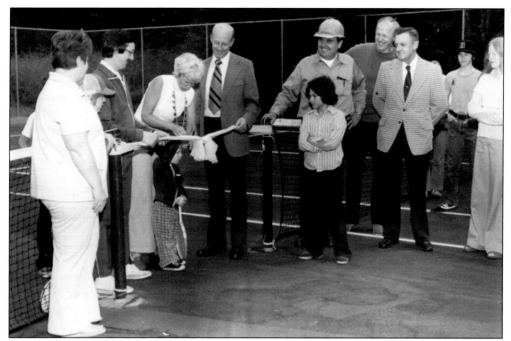

CEDAROAK TENNIS COURTS. Robinwood resident Carol Geldaker cuts the ribbon at the 1976 dedication ceremony of the Cedaroak Tennis Courts, which she raised money for. Included from left to right are Marilyn Oetken; unidentified neighbor; West Linn mayor Alan Brickley; Brickley's son, Craig, who is helping Carol Geldaker cut the ribbon; John Stuckey, Ph.D., superintendent of West Linn schools; unidentified neighbor boy; Gene Kerr; a volunteer; Chuck Geldaker; city manager Cliff Sanders; unidentified neighbor; and Heidi Geldaker. (Courtesy Carol Geldaker.)

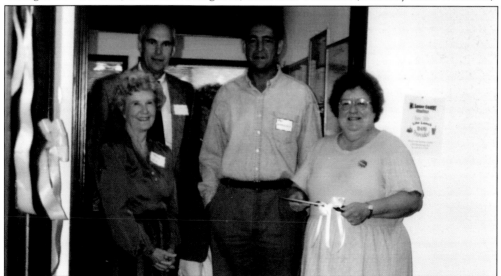

SENIOR CENTER PERMANENT HOME. Gathered for the 1999 dedication of the Reinke property, where the permanent home of the West Linn Adult Community Center would be built, are, from left to right, Mary Hill, the center's president; Scott Burgess, city manager; Ken Worchester, parks and recreation director; and Mayor Jill Thorne. The center was completed and formally dedicated in 2003 under Mayor David Dodds. The senior center organized officially in 1993. (Courtesy Mary Hill.)

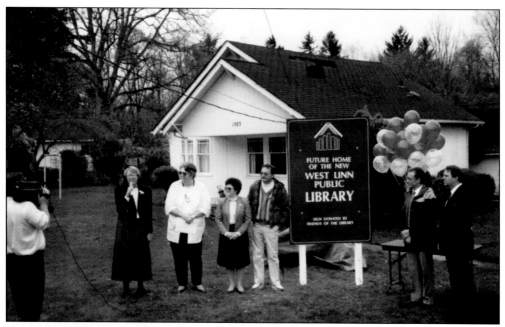

LIBRARY'S FUTURE HOME. Library director Pam Williams (above left with microphone) speaks at the dedication ceremony of the future home of the West Linn Public Library in 1988 on Burns Street. Prior to this, the library met at the old city hall beginning in 1939 and beginning in 1979 in the Bolton Fire Hall Annex. Next to Williams, from left to right, are West Linn mayor Kathy Lairson, city councilor Sherry Clyman, city councilor Jonathan Cox, city councilor Bob Stowell, and city councilor Mike Gates. (Courtesy Alan and Elsie Lewis.)

NEW LIBRARY FLAG CEREMONY. Alan Lewis (far right), a former Friends of the Library president, is seen helping with the raising of the flag at the newly constructed Burns Street West Linn Public Library during the 1989 flag dedication. Oregon City Elks donated the flag, while the West Linn Lions bought the flag pole for the new library. On the far left is late West Linn resident and Oregon City Elks member Ed Lind. (Courtesy Alan and Elsie Lewis.)

Six

THE THREE R'S
HISTORY OF EDUCATION IN WEST LINN

By 1897, one could identify 12 individual school districts that comprised what is now the West Linn–Wilsonville School District, including No. 34, now Robinwood, Marylhurst, Bolton, and Sunset; No. 105, now the Willamette area; No. 41, now Stafford; No. 96, now Pete's the Mountain area, which merged with Stafford; and No. 43, Mountain District, which consolidated with Stafford in 1943.

When it comes to individual schools, West–Oregon City—the current Sunset area—was the first to build its school in 1890. The original Sunset School was torn down in 1916 and, a year later, a new school was constructed, before a 1940 fire burned down the main building. In 1941, the present Sunset Elementary School was built.

Bolton joined the students at West–Oregon City School until 1892, when Bolton-area parents purchased a store from Mr. Cramer to house younger primary students. In 1922, Bolton's first school was built, housing grades one through eight. In 1950, the current Bolton Grade School was built.

In the Stafford area, there was a one-room log-cabin school in 1891 that was used until 1896, when the two-story Stafford School was constructed, complete with bell. In 1930, the present old Stafford School was built, and the main portion of the 1896 school was moved to become the gymnasium. In 1967, the present-day Stafford School was constructed, and the old Stafford School became the district's administration building.

A two-story Willamette Falls School was constructed in 1896, though children in the Willamette area attended school before that in Batdorf's store, beginning in 1894. In 1912, an exact replica of the two-story Willamette School was built and, in 1936, both were torn down to build a new one, which burned down in 1949.

Robinwood area students attended Bolton until the 1958 construction of Cedaroak Park Primary School. Several additions have been made to the school since then.

In 1919, the first temporary high school was constructed where the current Willamette School sits. Five girls received diplomas in 1920. That same year, construction began on a new high school on its present site on A Street, and students began attending the new school the next school year. Another building was competed in 1923. In 2004, the original 1921 and 1923 buildings were torn down to make room for the new West Linn High School, completed in 2006.

West Linn High School has had the following names: Union High School (1919–1931), West Linn Union High School (1932–1933), Oswego–West Linn High School (1934–1937), and West Linn High School (1938–present).

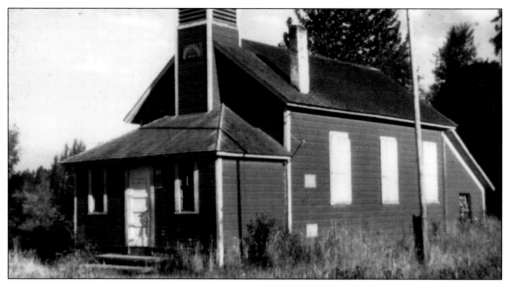

ADVANCE SCHOOL. Advance School, near Frog Pond Road, is shown in this 1941 photograph. The Advance Independent School District No. 67 formed before December 15, 1868. On May 29, 1943, Advance School District consolidated with School District No. 41 (Stafford), School District No. 43 (Mountain Road), and School District No. 96 (Pete's Mountain) to become School District No. 41. (Courtesy Clackamas County Historical Society.)

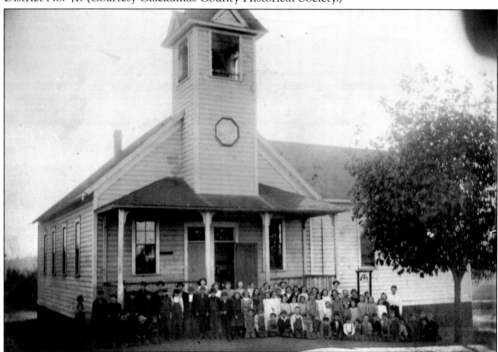

ORIGINAL STAFFORD SCHOOL. A one-room schoolhouse in the Stafford area served as school for children as early as 1891, and the Stafford School featuring the bell tower was built in 1896 on the current Stafford Road. It serves as the administration building for West Linn–Wilsonville School District today. Stafford District No. 41 formed prior to 1862. Students gather for this 1909 photograph outside of the 1896 Stafford School. (Courtesy Clackamas Historical Society.)

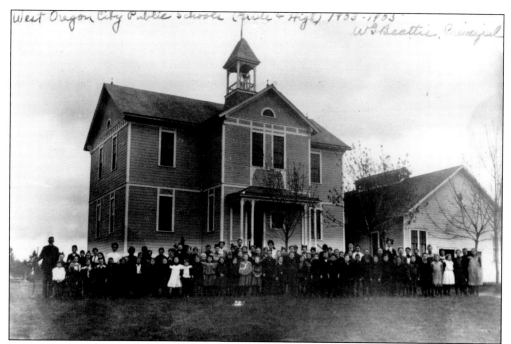

West Oregon City Public Schools (Grade & High) 1890-1905 W.B. Beattie, Principal

FIRST WEST–OREGON CITY SCHOOL. Built in 1890, this was the first school in the West Linn School District. Called West–Oregon City, the two-story school was built for grade school and high school students in what is now the Sunset area. Students gather in the front of the school in 1904 for this photograph. W. B. Beattie was principal. (Courtesy Clackamas County Historical Society.)

WILLAMETTE FALLS SCHOOL. The Willamette area formed District No. 105 on April 15, 1896, and Willamette Falls School was built the same year for students through 10th grade. The first four grades met on the lower floor and the other ones on the top floor. The small building to the right is the restroom, and note a person standing in the doorway. Between 1894 and 1896, Willamette students attended school at Batdorf's store. In 1912, an exact replica of the front building was constructed, as seen in the photograph. (Courtesy George Matile.)

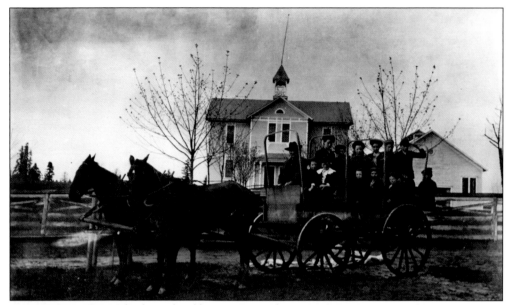

FIRST SCHOOL BUS. The first school bus service in the state of Oregon to provide transportation for its students is this two-horse-drawn carriage that transported students to and from West–Oregon City School in the current Sunset area of West Linn. The photograph is from 1904. Students came from the Rosemont area. (Courtesy Clackamas County Historical Society.)

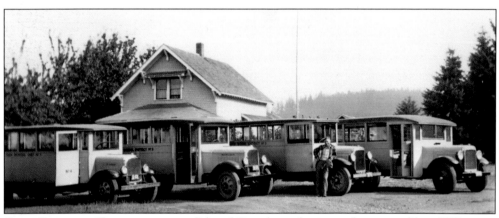

GROSS BROTHERS TRANSPORTATION. Edward Gross began busing students to and from Willamette Grade School in 1927. He stands here with his fleet of buses. Edward's sons Clarence and Harold Gross helped him out and took over upon his death. Edward Gross emigrated from Russia as a child, moving to Pete's Mountain. He eventually relocated to the Willamette area with his wife, Dorothy Clancy. Edward Gross was on the board of education from 1922 to 1927, and he was also a city councilor from 1930 to 1934. (Courtesy Esther Gross Betts.)

SUNSET SCHOOL BUILT IN 1917. The original Sunset School building, constructed in 1890, was torn down and this new one completed in 1917. The building burned down in 1940. In 1941, the current Sunset School was constructed. (Courtesy Clackamas Historical Society.)

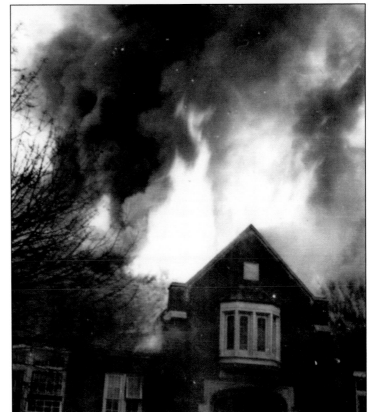

WILLAMETTE GRADE SCHOOL BURNS. The original Willamette Grade School of 1896–1912 was torn down in 1936 to build a new school under a Federal Grant Project. The building burned down on January 5, 1949. (Courtesy Toni Dollowitch Bernert.)

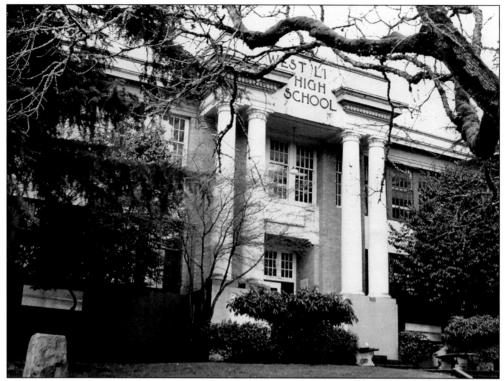

WEST LINN HIGH GETS NEW BUILDING. In 1919, the first high school was built in a temporary building on the site of Willamette Grade School while construction of a new high school occurred at the current high school location on A Street. The 1920 class had five graduates, all women. The class of 1921 got to use the new building with columns, as seen in the photograph. (Courtesy West Linn High School.)

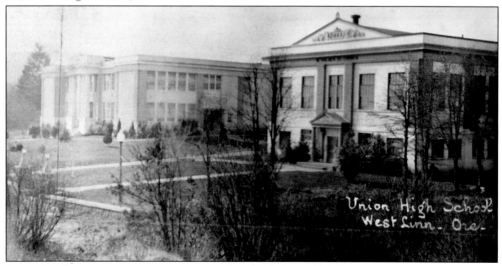

PHASES OF CONSTRUCTION. West Union High School's second building was completed in 1923 with space between the first and the second building. The name of the high school has gone as follows: Union High School (1919–1931), West Linn Union High School (1932–1933), Oswego–West Linn High School (1934–1937), and West Linn High School (1938–present). (Courtesy George Matile.)

ROYAL TURNAROUND. The next phase of construction at West Linn High School added a popular turnaround, which became the high school's main entrance in the 1950s and 1960s. Notice the lion statue by the door. There have been several versions of this turnaround, and since the most recent construction of the new building, there has not been a turnaround. (Courtesy West Linn High School.)

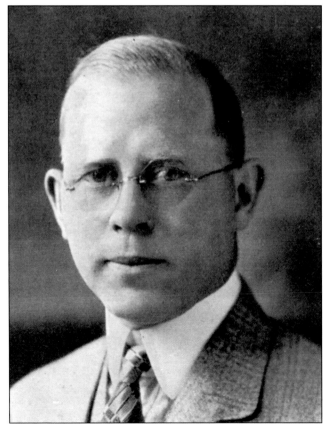

LONGTIME HIGH SCHOOL PRINCIPAL. John L. Gary was principal at West Linn High School from when it was housed at its temporary building in Willamette through the year 1942. (Courtesy West Linn High School.)

CEDAROAK PARK PRIMARY CONSTRUCTED. Cedaroak Park Primary School was built in 1958 with six classrooms. Prior to the school's construction, students from the Robinwood area attended Bolton. Over the next few years, several more classrooms and offices were added, as well as a cafeteria and a library. (Courtesy Mary Hill.)

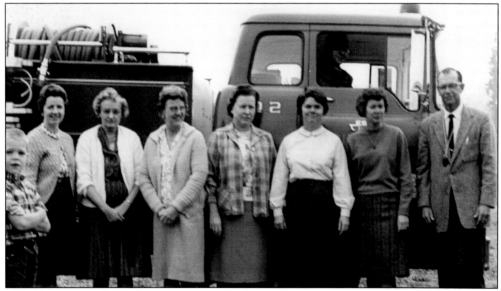

FIRST CEDAROAK PARK STAFF. The first faculty members of the newly constructed Cedaroak Park Primary School in 1958 are, from left to right, Martha Hastings, Mildred Tozier, unidentified, LaVern Blake, Miriam Adams, Donna Woodward, and principal Chuck Hill. Hal Gibbons is in the fire truck. The boy to the left is unidentified. Hill remained principal until 1968, then went to a Wilsonville school before becoming principal at Willamette School (from which he retired). (Courtesy Mary Hill.)

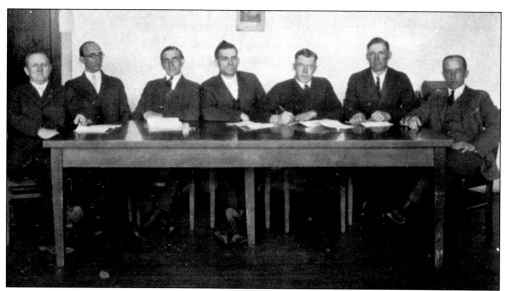

SCHOOL BOARD OF 1923–1924. The board of education of the 1923–1924 Union High School is pictured here. Members include, from left to right, W. C. McDonald of Bolton, Karl Buse of West Linn, Clem Dollar of Willamette, Ed Gross of Willamette, Karl Koellermeier of West Linn, Adolph Volpp of Willamette, and L. B. Shadle of Willamette. (Courtesy West Linn High School.)

SCHOOL WARDEN ANNA MCLARTY. Anna McLarty came to work at West Linn High School in 1948 in the school cafeteria. Later she was asked to be attendance secretary, where she greeted students for 15 years. "She was the warden," jokes her daughter, Sally McLarty, a longtime Bolton-area resident. Sally and her father, Matthew, also worked for West Linn schools; Sally as a Bolton School teacher and Matthew as a Bolton School custodian. (Courtesy Sally McLarty.)

SUPERINTENDANT'S LIFE. Chester Tunnell, a teacher in the West Linn School District from 1937 to 1943, returned as superintendent of the district in the 1946–1947 school year; he remained as head until 1976. When Tunnell became superintendent, the student body was made up of students from West Linn, Gladstone, Lake Oswego, and Lake Grove. Students were accepted based on tuition paid by their former high schools. (Courtesy Doug Tunnell.)

LIBRARIAN RETIRES. Elsie Lewis (left) was librarian at Willamette Middle School from 1970 to 1989. She celebrated her retirement in 1989 at a party held at Bill Bailey's house. She is joined by, from left to right Gary Eppelsheimer, a West Linn High School teacher, Eddie Dierickx, and Becky Gross Dierickx, a Cedaroak Park Primary School teacher. Elsie Lewis was the Friends of the Library president for West Linn Public Library from 1994 to 2006. (Courtesy Alan and Elsie Lewis.)

COACH SENT TO OLYMPICS. John Paul Brown taught and coached at West Linn High School from 1926 to 1961. In addition, he liked to fish. He lived in a house on school property. A baseball field at the high school is named after him with a sign that says "Welcome to John Paul Brown Field." He was so well liked and appreciated that the community decided to send him to watch the Olympics. George Matile, who as a student played basketball and baseball under Brown's leadership, shares: "In 1952 the community got together and sent Coach Brown to the Olympics in Helsinki, Finland. They earned $1500 so he could go; it was under the leadership of Chester Tunnell, the district's superintendent. Brown's first football team he coached at the high school went undefeated, and though they didn't have official state championships in the state at that time, they always considered that 1926 team a state champion." (Courtesy George Matile.)

ENTIRE STAFF WEST LINN HIGH. The entire staff of West Linn High School takes a break outside the school building in 1988. (Courtesy West Linn High School.)

STAFFORD SCHOOL 1893. Students from Stafford School in 1893 are pictured, from left to right, as follows: (first row) Harry and Carl Elligsen (not pupils), Adolph Delker, ? Delker, Theodore Schatz, Manuel Frey, and Charlie Christiansen; (second row) Edna Larsen, Mary Christiansen, ? Sauer, Mary Woelfle, Tera Athey, Christina Schatz, Ida Neubauer, Willa Frey, Rosie Schatz, ? Philips, and unidentified; (third row) Emma Athey, Ella Christiansen, Clara Athey, Dora Athey, and Emma Athey; (fourth row) Willie Polivka, Herman Reichle, Paul Reichle, John Reichle, Eva Athey, Blanche Phillips, Don Gage, Julius Reichle, Earl ?, and teacher W. B. Beattie. (Courtesy Clackamas Historical Society.)

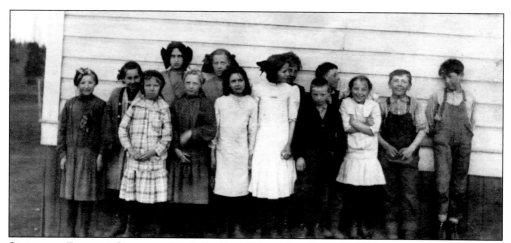

STAFFORD FOURTH GRADERS 1914. Stafford School fourth graders line up outside their school in 1914. From left to right are (first row) Daphne Hargan, Leta Tiedeman, Beata Jones, Albertine Frenzel, and Bennie Moser; (second row) Lela Tiedeman, Sabra Nussabaum, Gertrude Simmons, Alice Simmons, Daniel Keller (partially hidden), Clarence Aerni, Edna Aerni, George Rabick, and Stanley Oldham. (Courtesy Clackamas County Historical Society.)

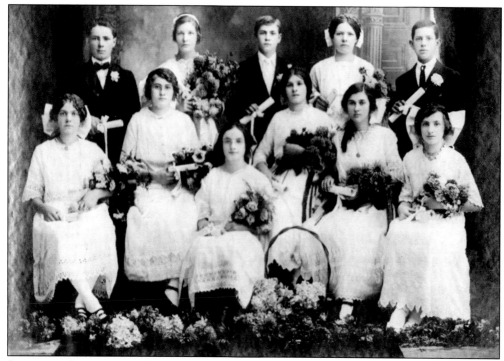

STAFFORD GRADUATING CLASS 1915. Pictured is the Stafford Grade School eighth-grade class of 1915. From left to right are (first row) Dora Oldenstadt, Suzie Miller, Lydia Moser, Bertha Moser, Christina Elligsen, and Vera Liedeman; (second row) Joe Rabick, Genneve Holmes, Earl Oldenstadt, Freda Keller, and Walter Shatz. (Courtesy Clackamas County Historical Society.)

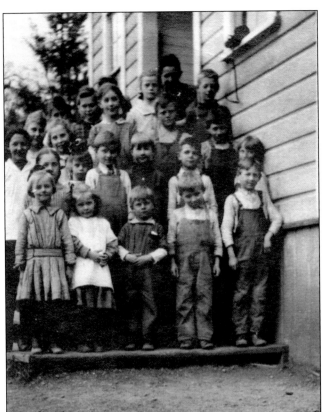

THE MOUNTAIN ROAD SCHOOL 1916. Students of the Mountain Road School (District No. 43) gather for this photograph in 1916. Included that year are Ella Christiansen, Agnes Bernert, John Anderson, Erwin Notdurft, Hilda Boeckman, Lillie Settje, Bernice Hodge, Nora Heinz, Mary Koellermeier, Fred Heinz, Helen Anderson, Donald Hodge, Elmer Settje, Willie Anderson, Fritz Boeckman, Henry Woolfolk, Johnny Knichrehm, Erwin Notdurft, Hilda Boeckman, and Freddie Settje. This district consolidated with Stafford in 1943. (Courtesy West Linn High School.)

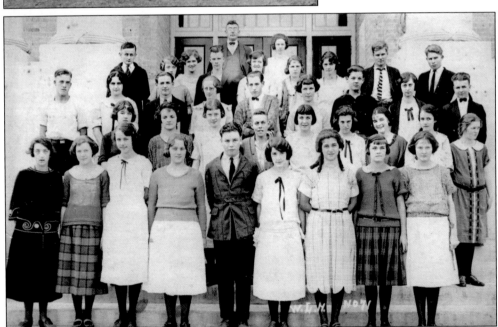

FIRST YEARS IN NEW HIGH SCHOOL. Students during the 1921–1922 school year at Union High School gather for a photograph outside their new school in West Linn. (Courtesy Clackamas County Historical Society.)

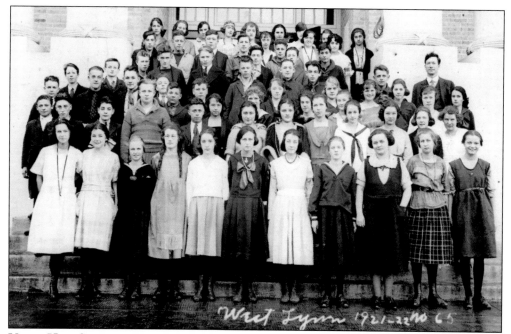

UNION HIGH SCHOOL, 1921–1922. Students pose for a photograph during the 1921–1922 school year outside their newly constructed building. (Courtesy Clackamas County Historical Society.)

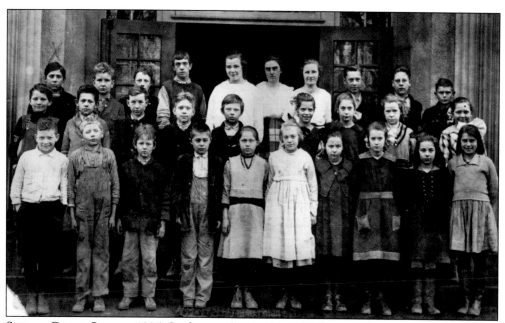

SUNSET GRADE SCHOOL 1925. Students gather for this 1925 photograph at Sunset Grade School. From left to right are (first row) unidentified, F. Pickle, Joe Zaconis, unidentified, Mary Zaconis, May Powell, Nella Garrison, Winifred Humphrey, Hattie Buse, and Julie Rimpkus; (second row) unidentified, John Fredericks, ? Montgomery, Harvey Nelson, Don Zaconis, Bertha Zirbel, Mildred Anderson, Rose Plikunis, and unidentified. The third row includes Louis Lytsell, Orville Charles, Wesley Kunzman, and Bertha Bethune. (Courtesy Julie Buse Hugo and Maxine Buse.)

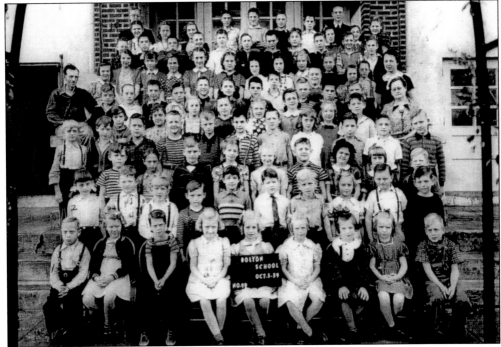

BOLTON 1939. The entire student body of Bolton School stands outside its building in 1939. Before this building was constructed in 1922, students met at Mr. Cramer's store, which parents purchased in 1892 to use as a school. Featured in the photograph are Matthew McLarty (fifth row, left), longtime custodian and Bolton resident; Ruth Kraxberger (sixth row, far right), first- and second-grade teacher; and just below her is Edna Bickner, third- and fourth-grade teacher. (Courtesy Sally McLarty.)

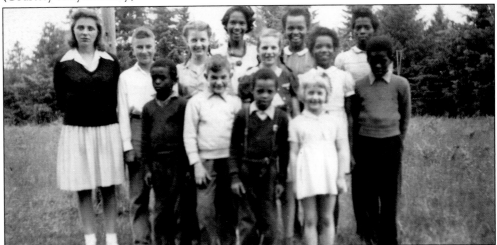

PETE'S MOUNTAIN SCHOOL. The last class of Pete's Mountain Grade School District No. 96 gathered before it closed for good in May 1943, when it consolidated with Stafford. Pictured from left to right are (first row) Kernan Bagley and Shirley Hellberg; (second row) Clyde Bagley, Bobby Yeomans, Rozella Yeomans, Darlene Bagley, and Don Bagley; (third row) teacher Jessica Holman, Bill Kaiser, Margie Hellberg, LaVerne Bagley, Phyllis Bagley, and DonaClair Bagley. (Courtesy LaVerne Bagley Brown.)

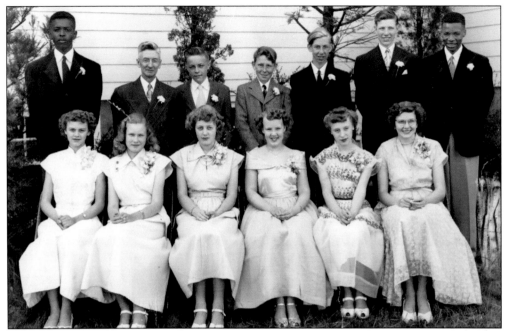

STAFFORD CLASS OF 1950. The students in the Stafford class of 1950 included Glen Ek, Clyde Bagley, Kernan Bagley, Orlon Gessford, Dorothy Hamnes, Shirley Hellberg, Lewis Jones, Virginia Lindberg, Betty Moser, Frances Moser, Donna Oldenstadt, and Alfred Wood. (Courtesy Clyde and Rachelle Bagley.)

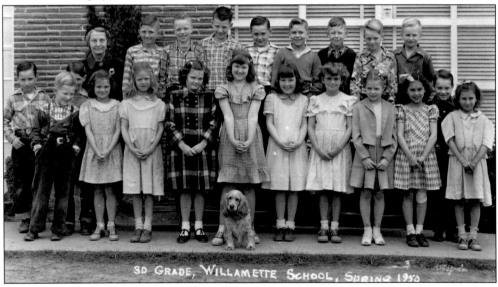

IN DOG YEARS. The third-grade class of Mrs. Larson in 1950 at Willamette Grade School is pictured with Carolyn Taggaret's dog. From left to right, students are as follows: (first row) Gary Winkleman, Bill Smith, Barry Schobe (partially hidden), Carolyn Hinkle, Betty Elliot, Melanie Younge, Carolyn Taggaret, Janet Greene, Jackie Moenke, Marilyn Gross, Norma Mouser, Roger Niemela, and Deana Bartholomew; (second row) Mrs. Larson, Marvin Moles, Jimmy Hamilton, Norman Bless, Charles Rice, Jerry Finch, Connely Plotts, Donny Wilkinson, and Jerry Schnelle. (Courtesy Lisa Yonge Lawer.)

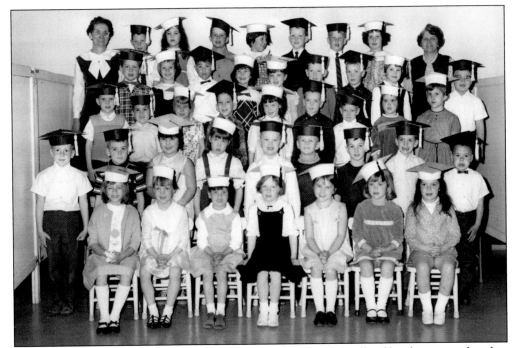

KINDERGARTEN IN CHURCHES. Before West Linn Public Schools offered kindergarten, churches stepped up to educate. The 1966 graduation day for kindergartners was complete with graduation caps at West Linn Baptist Church's kindergarten, the oldest kindergarten in West Linn. Monthly tuition at the West Linn Baptist—now New Life Church—Kindergarten was $15. Current pastor Scott Reavely says, "I still run into people who attended kindergarten here." (Courtesy New Life Church.)

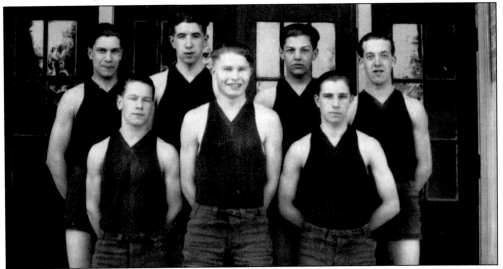

UNION HIGH BASKETBALL 1923–1924. The Union High School—now West Linn—basketball team from 1923–1924 played McVinnville, Colton, Independence, Dayton, Oregon City, Salem, Canby, and Milwaukie, winning 8 out of 15 games. The team's captain and center was Garnie Cranor. Other players included Jessie Mootry, Bruce Willson, Glen Smith, Herbert King, Marvin Hickman, and John Moffatt. (Courtesy John Klatt.)

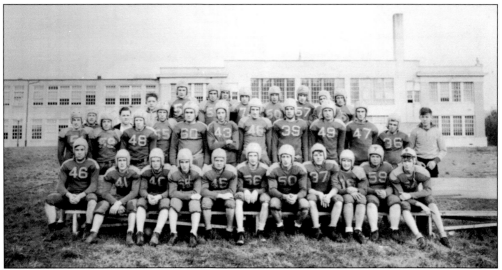

HIGH SCHOOL FOOTBALL 1944. The 1944 First Team A football squad from West Linn High School poses in complete uniform for its photograph outside the school. Football games were important Friday night events that drew people from around the community. (Courtesy West Linn High School.)

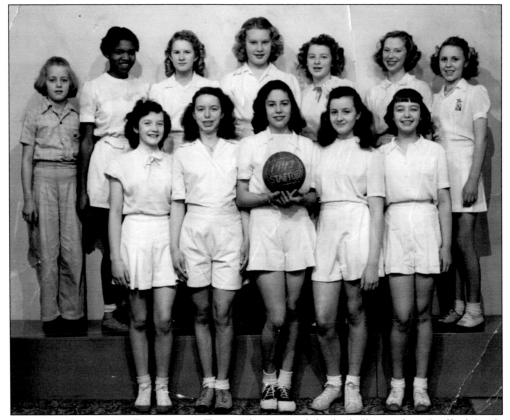

STAFFORD GIRLS 1947 BASKETBALL TEAM. The 1947 girls basketball team from Stafford Grade School gathers for a team picture. (Rachelle and Clyde Bagley.)

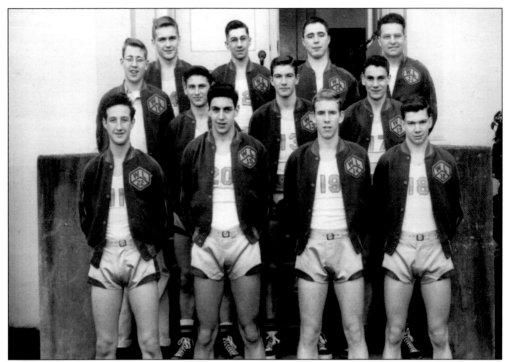

BOYS HIGH SCHOOL BASKETBALL 1948. The 1948 state basketball team from West Linn High School stops to pose for a photograph. They are, from left to right, (first row) Wayne Stewart, Bob Adrian, Dean Urfer, and Ken Gould; (second row) Charles Bamford, Carl Rennewitz, Chuck Beck, and George Matile; (third row) Dick Schleiss, Chet Stauffer, Bob Warner, and coach Sam Nixon. (Courtesy George Matile.)

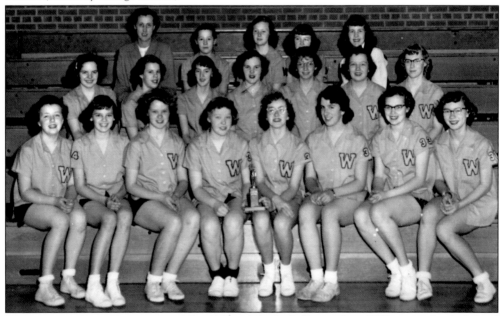

WILLAMETTE GIRLS BASKETBALL. The 1955 girls basketball team from Willamette Grade School poses for this photograph. (Courtesy Lisa Younge Lawer.)

MAY DAY QUEEN 1937. Marie Hellberg became May Day queen of 1937. The Hellberg family have deep roots in the Pete's Mountain area. (Courtesy West Linn High School.)

MAY DAY QUEEN 1955. In 1955, Janet Blattman was named May Day queen, and her escort was Dick Simantel. Today the tradition of a May Day court continues. Out of the nine male and female students selected to the May Day court, a May Day king and queen are crowned. In the past, the men were only considered escorts. (Courtesy West Linn High School.)

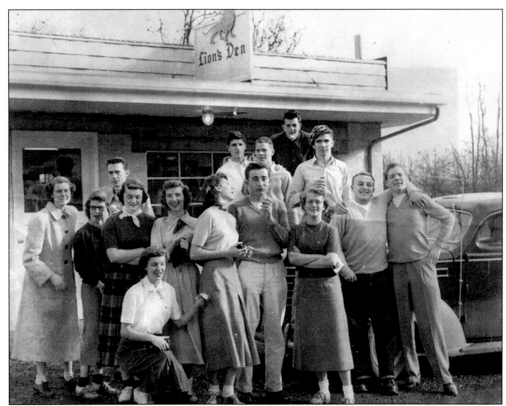

LION'S DEN. Students from the classes of 1949, 1950, and 1951 pose in front of the popular Lion's Den snack shop across from the high school. It was demolished in the 1990s. The building was very small, about 20 feet by 20 feet, and sat between a house and New Life Church. (Courtesy West Linn High School.)

LIONS DEN 20 YEARS LATER. Some of the same people who posed in the 1949–1951 photograph above return to the Lion's Den 20 years later. These include, from left to right: (first row) Ernie Rickard, Jim Thornburg, and Dave Dorsey; (second row) Bud Condart, principal Joyce Henstrand, Alden Rondeau, Sue Bradley, Larry Lee, Bob Greenwood, and Jim McIntosh. (Courtesy West Linn High School.)

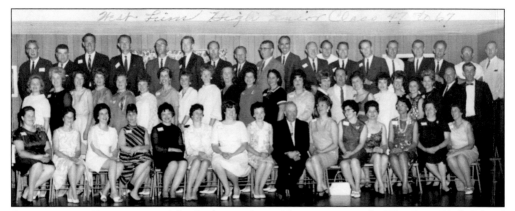

CLASS OF 1947 REUNION IN 1967. Gathering for its 20-year reunion, the West Linn High School class of 1947 in 1967 included popular coach and teacher John Paul Brown, who is seated in the front row, ninth from the left. (Courtesy LaVerne Bagley Brown.)

CLASS OF 1955. West Linn High School's class of 1955 gathers for its 50-year reunion photograph in 2005. (Courtesy Sally McLarty.)

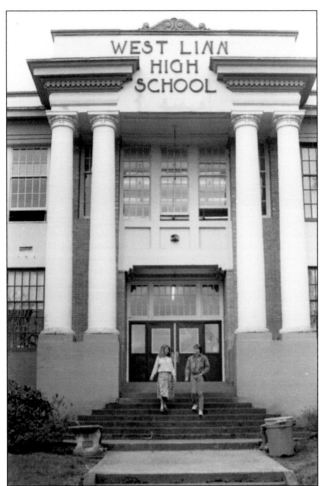

OUTSIDE OLD WEST LINN HIGH. Connie Phillips walks down the stairs in front of West Linn High School with Gayle Bless, who is now her husband. The photograph was taken about 1965, notes Sue Bradley. (Courtesy West Linn High School.)

CLASS OF 2008. The West Linn High School class of 2008 gathers outside the high school. Notable members of the class of 2008 include Hailey Niswanger, who was selected twice during her West Linn High School career to be part of the Grammy Jazz Band, which played at pre-Grammy events and at the post-Grammy party for the Grammy nominees; and Ali Super, a three-time state javelin thrower who was nationally ranked during her high school years. (Courtesy West Linn High School.)

Seven

THE PLACES YOU'LL GO
NEIGHBORHOODS, PEOPLE, PARKS, AND BUSINESSES

There are 11 neighborhood associations currently in West Linn, and each remains active as an individual entity yet also part of a whole. Some are older and others very new, but all contribute to the community feeling of West Linn. Business owners are often community members and make up the unique home-town feel of West Linn. Many families came to West Linn over a century ago and continue to remain here to this day. Others arrived later but have stayed to raise families. Adult children return home, often married and wanting their own children to grow up in West Linn.

Willamette maintains its historic edge, celebrating its centennial as an incorporated city in 2008. It was fully electrified in 1893, the same year New York City was planning electrification. With the completion of the 1888 suspension bridge, other parts of the west side of the falls were taking shape as well. In 1889, the plats of the west-side addition to Oregon City, Windsor, and Weslynn were recorded; in 1892, Sunset City and the Parker Hill addition to Oregon City were added; and Bolton was platted in 1896 by the Bolton Land Company, named for Edward and Pauline Bolton. The Holly Grove area, part of Bolton, developed two decades later.

In 1895, the German immigrant family Wanker purchased the 1851 land claim of James M. Athey, and eventually a descendant built Wanker's Corner at Stafford and Borland Roads. Rosemont Road, once a trail, was a transportation connection between Linn City and Tuality Plains, and many farms sprouted up along the route. Rural West Linn was home to many farms, some of which are still there, including the Ek and Elligsen farms, which both have roads named after them.

The water district of Robinwood was established in 1946, and Marylhurst Heights was platted nearby in 1947. Cedaroak, Robinwood, and Marylhurst were annexed to the city of West Linn in 1967.

Early business ventures included the 1895 Capen Shoe Factory in Willamette, which ran on electric power. The West Linn Inn opened in 1918 as housing for workers of the paper mills; it closed in the 1980s.

Parks are a big part of the City of Hills, Rivers, and Trees, including the newly established Maddox Woods.

WEST LINN GREETING. Visitors to West Linn coming off Interstate 205 onto Willamette Drive, Highway 43, are greeted with this tile sign, "Welcome to West Linn." Artist Marla Baggetta had a hand in designing the sign for the city. (Courtesy author's collection.)

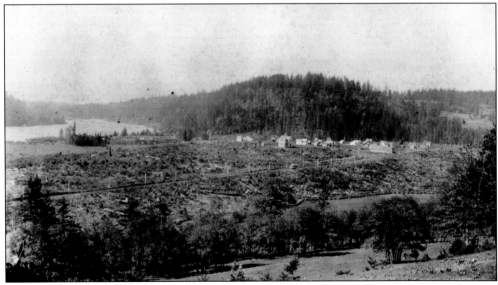

OLD WILLAMETTE. The Willamette area is shown in the late 1800s or early 1900s. Note Willamette Grade School, which was constructed in 1896, in the middle of the photograph. The electric trolley line running from the Linn City area along the Willamette River is in the middle of the photograph. (Courtesy Oregon Historical Society.)

SCHNOERR PARK. Gustav Schnoerr, an 1886 emigrant from Germany, gathered other German emigrant families to his property, which was located near Willamette Park, directly across the Tualatin River. People traveled by streetcar to Willamette, then walked up the hill or docked at the steamboat landing on his property. Activities in the 15-acre park included picnicking and dancing. The Schnoerr family operated the park into the 1930s. Now it is covered with houses, notes Mike Gates, former city councilor. (Courtesy West Linn Historic Advisory Board.)

DOWN ON THE FARM. Shown on the Ek farm in Stafford are August Ek, with his son, Ewald (on the cow), and the Estberg twins. Peter Hans Estberg and his wife Christine Ek Estberg arrived in rural West Linn from Sweden in the early 1900s, earning money logging Pete's Mountain. Christine sent for her nephews, August and Axel Ek, in Sweden, and they arrived in the early 1900s. Axel moved on to Portland for better living conditions, while August and his wife Signe built their lives on the land here. The Estbergs moved on to Portland, as well. (Courtesy Glen and Rose Ek.)

RURAL WEST LINN. The Ek family raised pigs, chickens, and cows on their farm in rural West Linn. Children such as Ewald, the son of August and Signe Ek, pictured here in 1914 at age two, worked alongside their father (out of view at right). August's grandson, Glen Ek, lives with his wife, Rose, in the same area. "He called it 'Gus Ek's farm.' He liked to raise pigs. He loved pigs and of course he loved horses too," Glen Ek shares. (Courtesy Glen and Rose Ek.)

OLDEN DAYS TRANSPORTATION. Signe and Gus Ek, with son Ewald, are off on a ride to visit friends in Portland about 1914. The house behind them is the original Ek house with a newer version of the "Ek Farm" sign along the road, in front of the house still owned and lived in by the Ek family. The road is now called Ek Road. (Courtesy Glen and Rose Ek.)

THE STORY CONTINUES. Ewald married Esther Ek, and they pose in this 1929 photograph in front of the Ek family home they lived in. They farmed the land and raised animals for most of their lives. Esther Ek was one of the grand marshals, along with Harold Gross, in the 2008 Willamette Centennial Celebration themed West Linn Old Time Fair parade. (Courtesy Glen and Rose Ek.)

RURAL WEST LINN. When people went on vacation, they brought their kids to board and work at the farm, explained Glen Ek, grandson of Gus Ek and son of Ewald. Glen runs the Ek Farm today along with his wife, Rose Ek. August Ek is in the back row, third from the left, jokingly wearing a woman's hat and holding son Ewald. (Courtesy Glen and Rose Ek.)

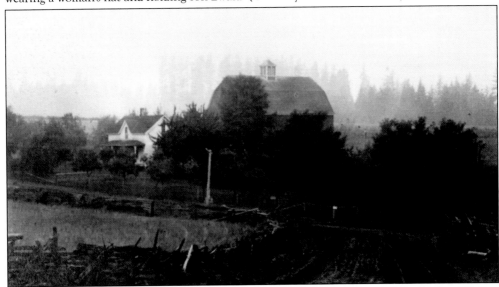

TIEDEMAN FARMS. In 1850, Nathaniel Robbins built this house and barn off Stafford and Delker Roads. Nathaniel married Zobeda Tiedeman, whose family is originally from Germany. They ran a dairy farm. "My dad would take those six gallon milk jugs and run them down with a horse team along Rosemont Road—it was an old dirt road—and he'd take them to Lake Oswego and sell them there," recalls David Tiedeman of his father, Emerson. (Courtesy Clackamas County Historical Society.)

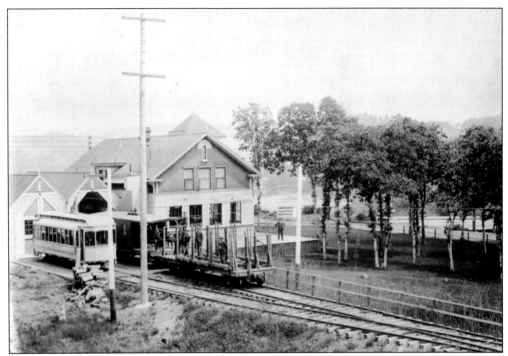

TROLLEY STATION. In 1927, streetcars were taken off Willamette Falls Drive, and buses began to operate. This is the trolley station in which city hall met until the new building was constructed in 1936, after the old wooden station, shown here, was torn down. (Courtesy Clackamas County Historical Society.)

ELECTRIC RAILWAY. The Willamette Falls Electric Railway was built in 1891 and was used to haul cordwood to the mill. It came from the Willamette area and headed toward the mill. Notice the telephone/electric poles in the background, which are some of the first in existence. (Courtesy Clackamas County Historical Society.)

ELLIGSEN FARM. Katherine and George Elligsen moved to the Stafford area from Germany in the late 1890s. The Elligsen farm was eventually passed down to Ralph Elligsen, who still lives there. A road in the Stafford area of West Linn near Wilsonville is named after the Elligsen family. This sign still graces the side of their farm. (Courtesy Esther Gross Betts.)

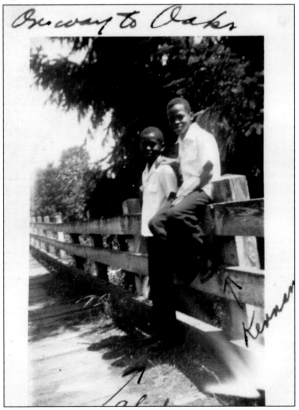

WEISS BRIDGE. Clyde Bagley (left) and Kernan Bagley pose for their sister LaVerne, who snapped this photograph in 1946 of the boys on Weiss Bridge over the Tualatin River from Willamette to Pete's Mountain. They had walked from their Pete's Mountain home to Willamette to catch the bus to Oaks Park in Portland to hear their sisters sing on *Stars of Tomorrow*. The wooden bridge has since been replaced. (Courtesy LaVerne Bagley Brown.)

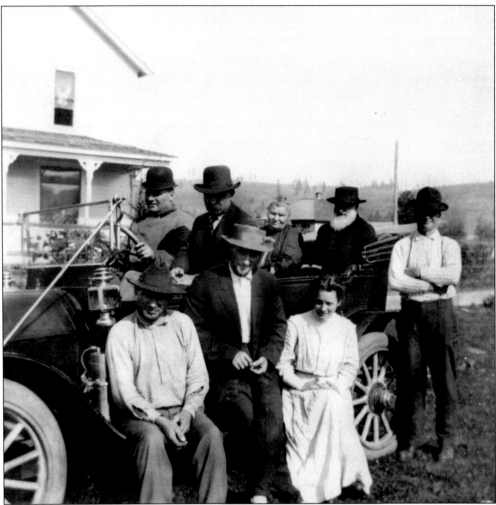

GROSS FAMILY AND THE DURANT CAR. Christine and Gottlieb Gross, who were originally from Germany, are pictured with their five sons, one daughter-in-law, and their Durant car in the early 1900s in front of their 1611 Sixth Avenue home. Pete's Mountain is in the background. From left to right are (first row) Ferdinand Gross, Edward Gross, and Laura Minnie Elligsen Gross, who is married to Edward Gross; (second row) Mike Gross, Sam Gross, grandma Christine Gross, grandpa Gottlieb Gross, and Guy Gross. Christine and Gottlieb arrived in Willamette in 1890, leaving their sons on the farm. Edward moved to Willamette in 1911, into the house he built for himself and his new wife, Laura Minnie Elligsen Gross. In 1912, Guy Gross and Minnie Fredericks Gross moved to their home in Willamette as well. Members of the Gross and Elligsen families remain in Willamette and other parts of West Linn today. (Courtesy Esther Gross Betts.)

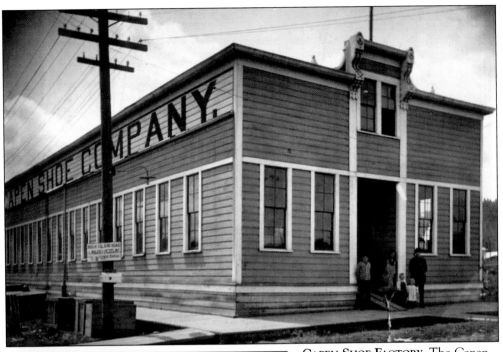

CAPEN SHOE FACTORY. The Capen Shoe Factory was established in the Willamette area of West Linn in 1895 by Ellery Capen (left in the white buttons) who represents the third generation involved in manufacturing shoes and boots. The second man from the left, in the overalls, is Ellery's son, Frank. Ellery's grandfather and father met footwear needs in Massachusetts. Ellery arrived in downtown Portland, Oregon, in 1876 to set up his own shoe business. In 1892, he moved his business to Willamette Falls, completing the Capen shoe factory there in 1895. Ellery's son, Frank, continued the trade until he and his wife, Hattie, and their eight children moved to Washington in 1918. One of Frank and Hattie's children, Margaret, is seen in 1914 with a grammophone in the below photograph, which has Willamette School in the background. (Above, courtesy Rich Capen; below, courtesy Charles Awalt.)

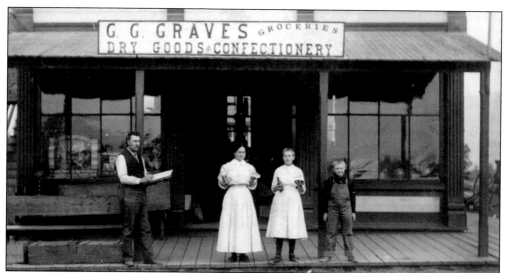

G. G. GRAVES GROCERIES. Located on the southeast corner of Fourteenth Street and Willamette Falls Drive was the G. G. Graves Groceries and Dry Goods confectionery, a popular spot in the town of Willamette. Shown are owner G. G. Graves as well as Laura Elligsen and two unidentified children. Besides the Graves family, the Batdorfs, Buckles, and Millikens owned the general store housed here. School met upstairs for a while, beginning in 1894, as did Willamette United Methodist Church. (Courtesy Esther Gross Betts.)

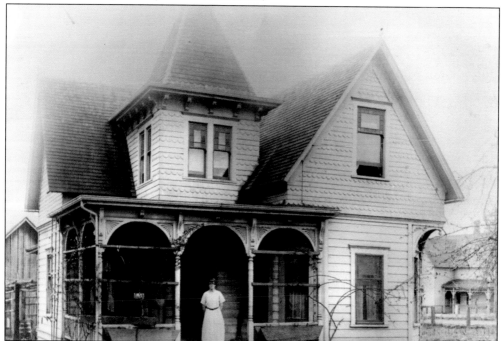

JOSEPH H. RALSTON HOUSE. The original owner for this 1895 Queen Anne home was Joseph H. Ralston, whose uncle Joseph H. Ralston was director of Oregon Woolen Mills. He was also one of the original signers of the petition for Oregon's statehood. Other families who have lived here include the Zacurs. Pictured is Verle Zimmerman Zacur. A movie was filmed here in the 1990s. (Courtesy Ruth Offer.)

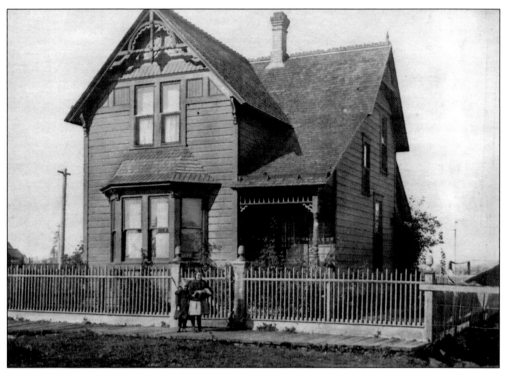

JONES-FROMONG HOUSE. The Jones-Fromong House, built in 1893, is located in Willamette. The Jones family purchased the house from Willamette Falls Electric Company in 1895. Then, in 1899, Andrew Fromong bought the house. Others who have lived here include Maxine Knapp. The Knapps, after whom an alley in Willamette is named, owned the drugstore in that area for 50 years. (Courtesy Teresa Choate Loriaux.)

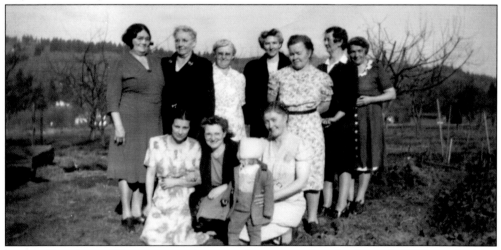

LADIES OVERLOOK WILLAMETTE. A group of women gathers in the early 1930s overlooking what was the Karbs Hill dairy (left), which was to the right of what is now Salamo Road. Pictured from left to right are the following: (first row) Agnes (Dollowitch) Bernert, Mary (Dollowitch) Bernert, Olivia Hellberg's child, and Olivia Hellberg; (second row) Lydia (Failmetzger) Moenke, aunt Louise Failmetzger, Elise Hellberg Volpp, Agnes (Bernert) Goldade/Parker, Bessie Criteser, Emma Shipley, and Minnie Kaiser. (Courtesy David and Judy Shipley.)

GREYDIGGER HEIGHTS. Sitting in a wagon overlooking Greydigger Heights in 1944 are, from left to right, siblings Jean Shipley and David Shipley and cousin Teri Walker Shipley. The chicken house is to the right. This was on the property of Frank and Emma Shipley's house on Thirteenth Street in Willamette. They called the area Greydigger Heights for the squirrels. At the foot of the hill was Karbs Dairy, a popular destination for milk. "We used to walk to Karbs Dairy to get milk," says David Shipley, who still lives in Willamette with his wife, Judy. (Courtesy Dave and Judy Shipley.)

BERNERT BROTHERS. This was the Willamette-area home of Joe Bernert and Agnes Dollowitch Bernert with their children out front. In the 1944 photograph are, from left to right, Jim Bernert in his navy uniform, Ray, George, and Joe, and in the front with the sailor hat is Tom. Originally from Germany, the Bernert brothers arrived in Willamette and Pete's Mountain in the 1880s and started a log-towing business on the Willamette River. (Courtesy Toni Dollowitch Bernert.)

H. T. SHIPLEY'S COW WITH TWINS. This picture looks northwest from Thirteenth Street and Willamette Falls Drive in the Willamette area of West Linn in the early 1900s. Harry T. Shipley's cow had one set of triplets and one set of twins. Cows were allowed to roam free in the area, one of the main reasons for fenced yards. Note the fenced house in the background. (Courtesy Dave and Judy Shipley.)

A SIGN OF THE TIME. West Linn was very rural, as this city sign attests. Cows were known to roam freely during baseball games in the park, recalls Harold Gross, who is 95 in 2008. He is a lifelong resident of Willamette. (Courtesy City of West Linn.)

Two Boys on Donkeys. David Shipley (left) and Ron Cox, who is from the Fromong family, hitch a ride on the Fromong family donkey in the Willamette area. (Courtesy Dave and Judy Shipley.)

HAROLD GROSS AND HIS PUMPKINS. Harold Gross liked to grow pumpkins as well as other crops in a 7-acre area—what is now Willamette park—that belonged to his family. Harold and his brother Clarence would lead cattle down to the area by the river to graze. The area, now called Pumpkin Patch Field, is where the baseball field at Willamette Park is. Gross became known as the "Pumpkin Man," because he'd sell pumpkins in his front yard on the honor system. (Courtesy Harold Gross.)

FIFTH GENERATION. Posing outside their Willamette-area home are Tuor family members, a fifth-generation West Linn family. From left to right are (first row) Dennis Newton, Mike Newton, and Anthony Hyatt; (second row) Maxine Tuor Newton, Gordan Tuor, Audrey Tuor-Hyatt, Anthony Tuor, Mayme Tuor, Harry Tuor Sr., Philip "Bugs" Tuor, and Bill Tuor; (third row) Everett Newton, May Tuor, Waldron Hyatt, Mary Lou Hyatt, Harry Tuor Jr., Bertha Tuor, Evelyn "Babe" Tuor, and Bill Tuor's first wife. (Courtesy Marsha and Dick Gross.)

FIELDS BRIDGE. Joseph Fields offered ferry service to cross the Tualatin River until about 1862, when the first covered Fields Bridge was constructed. The next four Fields Bridges were slightly downstream, and all of them are at the end of Dollar Street. The one pictured here was built in 1926 and lasted until 1953. They are located at Fields Bridge Park, a 19-acre natural area along the Tualatin River. A meteorite interpretive trail was recently added to the park. The Willamette Meteorite Interpretive Trail was dedicated here on August 23, 2008, featuring a new Willamette Meteorite replica. The family members of Ellis Hughes, who discovered the meteorite in 1902, attended the dedication. (Courtesy John Klatt.)

OSWEGO HILLS WINERY. Sarah and Richard F. Whitten arrived in 1852 to claim land in the Rosemont area, but in 1856, Richard drowned at the Willamette Falls. The land switched ownership several times before Kenneth B. and Frances C. Hall's purchase in the 1940s; they raised Arabian horses and Aberdeen-Angus cattle. Jerry Marshall acquired the property in 1996 and has been restoring the barn structures while building a winery with his family. (Courtesy Oswego Hills Winery.)

FORMER WORLD CLASS EQUESTRIAN CENTER. Kenneth B. Hall purchased the farm on Rosemont Road from Czechoslovakian immigrant James Spousta and built a world-class equestrian center that hosted the likes of Roy Rogers's Trigger and Buttercup. Rosemont Road was a former footpath to Tualatin Valley. Jerry Marshall, who had lived with his family near the farm for 25 years, purchased the land, which he turned into Oswego Hills Winery, in 1996. (Courtesy Oswego Hills Winery.)

WEST LINN INN. The West Linn Inn, also known as the West Linn Hotel, was built in 1918 for workers at the paper mill. According to some, the inn was originally constructed to house strike breakers when regular mill employees tried to organize a union and strike. The inn had 85 rooms and a restaurant with a long veranda running the length of the building that overlooked the Willamette River, providing a view of the falls, the mills, and the lower level of Oregon City. During World War II, the inn was used as a dormitory for men from all over the country who were brought to help keep the mill running. The Crown-Zellerbach Corporation ran the inn for many years before closing the hotel section. The restaurant remained open until the entire building was torn down in 1980. West Linn Inn restaurant employee Rose Ek shares that there was even a bowling alley at the inn. (Courtesy Clackamas County Historical Society.)

OLD BOLTON. Here is a view of the Bolton area before it was developed. George, Pauline, and M. J. Bolton acquired part of the Daniel Dean Thompkins Donation Land Claim sometime before 1887. E. G. and Maria S. Caufield, Tom P. Randall, and H. H. Johnson purchased some land and formed the first plat of a town site named Bolton in 1890. They established the Bolton Land Company. The streets running north and south are named after early settlers and alphabetically include the following: Atkinson, Barclay, Caufield, Devenport, Elliot, and Failing. (Courtesy Oregon Historical Society.)

McLEAN HOUSE. Edward McLean was born in 1886. The son of a Presbyterian missionary, he became a doctor, setting up private practice in Oregon City. He also traveled as a physician. He built his house in 1927 in West Linn on property that was part of the Hugh Burns Donation Land Claim. He and his wife, Anne, raised their five children here and sold their house to the city in the 1970s. The house is run by the Friends of the McLean House. (Courtesy Michael R. Anderson.)

DOROTHY MADDAX. Virgil and Dorothy Maddax lived on 7 acres of land by the Willamette River for 50 years in the Bolton area. In 1999, they donated part of their land to the City of West Linn to preserve the beauty. It is called Maddax Woods. Dorothy Maddax is seen on the right side of this photograph. (Courtesy Alma Coston/Friends of Maddax Woods.)

ORIGINAL HOUSE IN MADDAX WOODS. Dorothy Maddax was known as the "Geese Lady." She loved wildlife and nature, and the city has preserved the area as such. A trail is available to walk on, and during the holiday season, there is a lighting of the Maddax Woods where visitors can stroll on lighted trails along the Willamette River. An active Friends of Maddax Woods keeps the area beautiful. (Courtesy Alma Coston/Friends of Maddax Woods.)

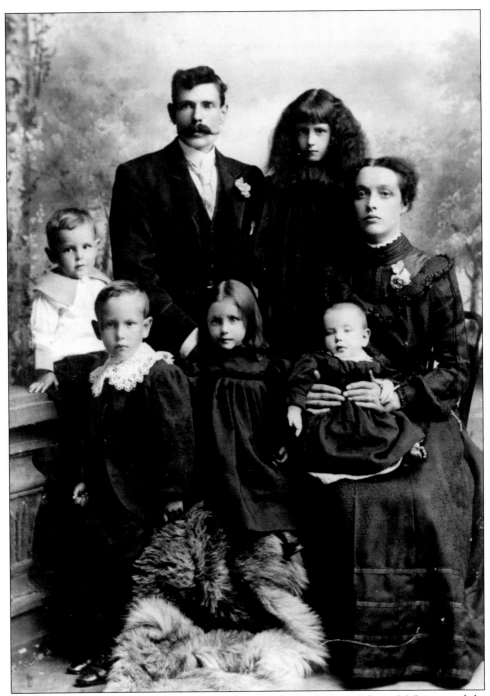

EARLY BOLTON FAMILY. Kennedy McLarty, his wife, Elizabeth "Lizzie" Scott McLarty, and their five children gather for this 1902 photograph in Ireland before Kennedy departs for America. From left to right are (first row) William James, Isa, and Martha Jane (the baby on Lizzie's lap); (second row) Matthew (age 2), Kennedy, Mary (the oldest daughter), and Lizzie. Kennedy made the journey alone in 1903, and his younger brother, Hugh, followed a year or so later with Lizzie and the children. They all settled in the Bolton and surrounding areas. (Courtesy Sally McLarty.)

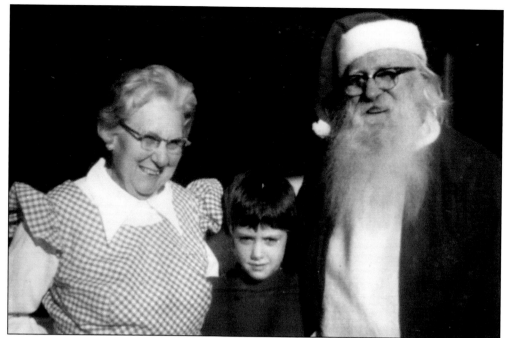

MR. AND MRS. WEST LINN. Herman Buse (dressed as Santa Claus), Zennah Buse, and granddaughter Julie pose for a Christmas celebration. Herman moved to the Sunset area of West Linn in 1910 at the age of nine. He and his wife, Zennah, were christened "Mr. and Mrs. West Linn" for being so active in the community. Herman worked at Crown-Zellerbach Paper Mill for 23 years, served on the West Linn School Board and on city council, and volunteered as a firefighter. He was honored by Mayor Frank Schumaker Jr. for 50 years of community service. (Courtesy Julie Buse Hugo.)

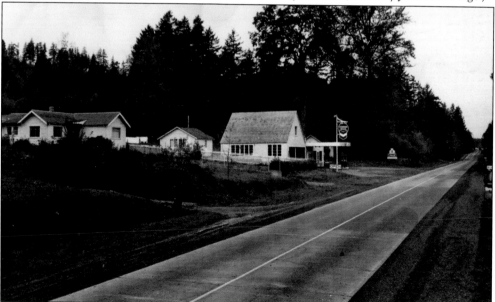

OLD ROBINWOOD. Looking north on Willamette Drive in Robinwood in the mid-1940s, the former Boswell Chevron station is seen. It was eventually replaced with Ed's Mufflers, but today it is the Dog Club of West Linn. (Courtesy Clackamas County Historical Society.)

THE CARL BRAUN HOUSE. Gracing the neighborhood at 20375 Willamette Drive near the border of the Bolton and Robinwood neighborhoods is the Carl Braun House. Built in 1927–1928, the original owner's ham radio equipment was able to reach to the South Pacific. During World War II and the Korean War, he was able to connect GIs with their families in the United States. The 145-foot radio tower is still in the backyard, and the basement, which served as a party room, was outfitted with relics from the battleship *Oregon*. (Courtesy Dee and Sherri Burch.)

SOURDOUGH WILLY'S BAKERY. Will and Grace Earhart opened Sourdough Willy's on December 4, 1986, at 18711 Willamette Drive in the Robinwood area of West Linn. "Our sourdough starter traveled from the vast regions of Spain, with sheepherders to South America to Central America to Mexico during the Pastry Wars of 1890. To a bakery in San Francisco," shares Will Earhart. People come for the bread, sticky buns, cookies—and the stories. Children Al and Grace are pictured as well. Will and Grace's son Tom perished in an automobile accident in 2007. (Courtesy author's collection.)

Eight

CULTURE
SERVICE ORGANIZATIONS
AND CELEBRATIONS

West Linn is rich in its homegrown, small-town traditions celebrating creative life on the river. Service organizations, churches, and various clubs have sprouted up over the years, which creates the culture of West Linn. From small-town baseball games in the 1920s and 1930s in historic Willamette, to the West Linn Old Fashioned Fair, to the Christmas parade, to the West Linn Arts Festival, to the Willamette Falls Locks Festival, to the West Linn Farmer's Market, West Linn is filled with culture.

The first church building on the west side of the falls was the Willamette United Methodist Church, which opened its doors in the Willamette area of West Linn in 1908 and was officially dedicated on September 12, 1909. Willamette Methodist's minister came from the Oregon City Methodist congregation, established years before along with other churches and missions in Oregon City. Church services were held in Linn City around 1850, but no special building was constructed, notes local historian John Klatt. Additional churches slowly were established, including Willamette Christian Church in Willamette, West Linn Baptist Church in the Bolton area, and the West Linn Lutheran and the Emmanuel Presbyterian Churches in the Robinwood area.

The West Linn Lions Club celebrated its 50th anniversary in 2003 and continues its tradition of being active in the community, helping schools, Scouts, non-profits, and the community at large; especially popular are the "Lion Burgers," topped with grilled onions. The West Linn Lions sponsor Boy Scout Troop 149, which celebrated its own 50 years in 2006. The River View Lions are known for their "Lion Paws" at local festivals.

The city of West Linn hosts various yearly community gatherings, many of them begun by a handful people. The West Linn Old Time Fair is such a celebration, with grange and church roots in the 1950s. It remains the city's most popular summer tradition. Many service organizations, churches, schools, and businesses participate in this yearly three-day outdoor party in Willamette.

Other, newer additions to West Linn's culture include the Willamette Falls Locks Festival, West Linn Farmer's Market, the West Linn Arts Festival, and the Art Festival in the Forest at Mary S. Young Park. The city hosts various concerts and movies in the parks.

West Linn has over 600 acres of parkland, ranging from parks for sports, picnicking, and playgrounds to nature parks.

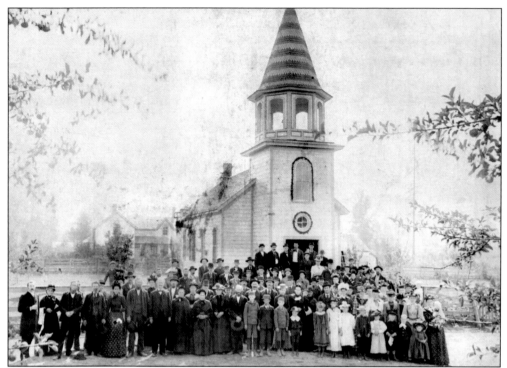

FROG POND CHURCH. Frog Pond Church, officially called Meridan Evangelical and Reformed Church, is shown here with churchgoers on its Dedication Day, June 18, 1882. Their dedication verse was: "We came unto the land whither Thou sendest, and surely it floweth with milk and honey." (Courtesy Esther Gross Betts.)

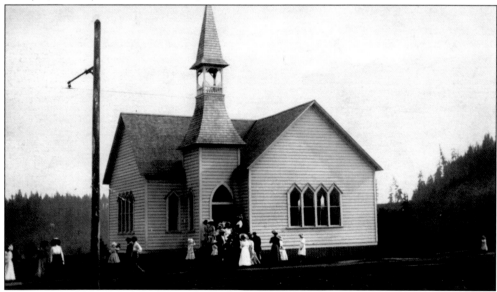

WILLAMETTE UNITED METHODIST CHURCH. Located at 1683 Willamette Falls Drive, Willamette United Methodist Church was founded in 1908 and formally dedicated on September 12, 1909. It remains active in the community today. Look closely and see the Willamette Falls Railway tracks in front of the church. (Courtesy Willamette United Methodist Church.)

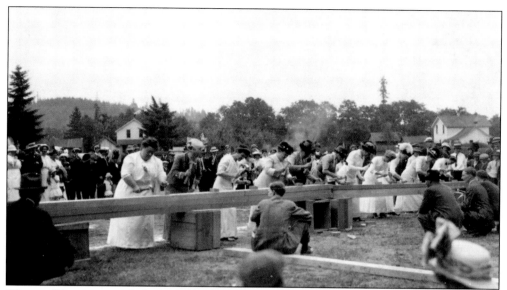

WOMEN HAMMERING. Sadie McFall, who has been a member of Willamette United Methodist Church, guesses that this photograph of women dressed up hammering while others watch shows a ground-breaking ceremony for the church in the 1900s or a contest of some kind around the same time. (Courtesy Willamette United Methodist Church.)

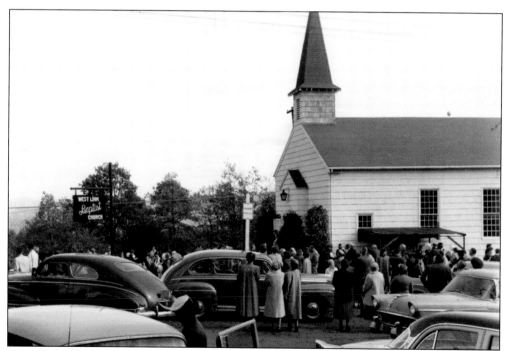

WEST LINN BAPTIST CHURCH. On Sunday, July 13, 1947, West Linn Baptist Church dedicated its new building, seen here in a 1956 celebration. Located across from West Linn High School, the building is a converted army chapel moved from Camp Adair, a temporary World War II military quarters and training facility near Corvallis that was deactivated in 1946. The church's new name is New Life Church. (Courtesy New Life Church.)

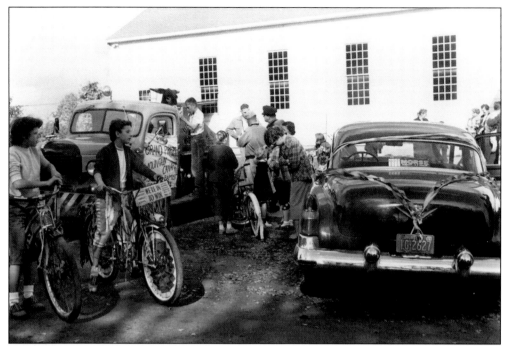

DONKEY IS THE PRIZE. West Linn Baptist Church participates in a worldwide Sunday school competition in 1956 to encourage people to come to church. The grand prize for Worldwide Sunday School Day at West Linn Baptist Church was a donkey, seen in the truck. The church is now called New Life Church. It has offered high school students free coffee and treats every school morning in its building for over 10 years. (Courtesy New Life Church.)

EMMANUEL PRESBYTERIAN CHURCH. Emmanuel Presbyterian Church, in the Robinwood area of West Linn, formed in 1961. The church is active in the community, offering its building for Robinwood Neighborhood Association meetings; a private school with kindergarten through sixth grade; and Beit Haverim, the South Metro Jewish congregation; among other uses. Pictured are the building and the old bell tower, which was built in 1969. Notice the old oak tree in front of the church, which was the inspiration for the name of the street (Cedaroak Drive) the church and school (Cedaroak Park Primary School) are on. (Courtesy Emmanuel Presbyterian Church.)

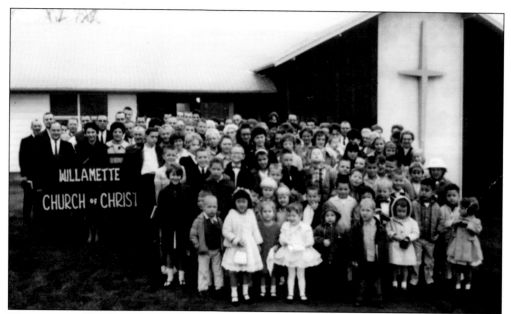

WILLAMETTE CHRISTIAN CHURCH. Outside their newly constructed church building on Tenth Street, members of Willamette Christian Church gather in 1962. Prior to this, members met at Willamette Falls Fire Hall and in homes since forming as a church in 1957, notes George Perdue, one of 13 original members. The church is building a new worship center off Salamo Road and Bland Circle. (Courtesy Willamette Christian Church.)

YOUTH GROUP 1968. Members of the Willamette Christian Church youth group from 1968 are pictured outside of the church's Tenth Street building. From left to right are (first row) Carol Woodruff, Chris Repogle, unidentified, Dawn Neves, and Barbara Marsh; (second row) three unidentified, Dan Fowler (who later became the mayor of Oregon City), two unidentified, Dean Marsh, Gwen Bowers, Ken Marsh, Nancy Fowler, unidentified youth leader, and Lee Dummer, the youth sponsor. (Courtesy Willamette Christian Church.)

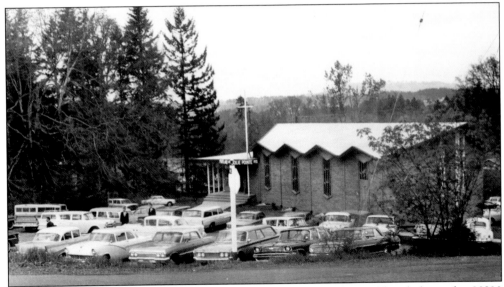

WEST LINN LUTHERAN CHURCH. In August 1962, West Linn Lutheran Church, located at 20390 Willamette Drive, elected its first church council, which included the following: Pres. Howard Bottemiller, Clarence Englund, Howard Fetz, Clarence Gross, Charles Geldaker, James Jennings, Orris "Bud" Jennings, Irvin Koellermeier, and Gerald Ronning. Dedication of the new building was held on May 12, 1963. (Courtesy West Linn Lutheran Church.)

NEWLY CONFIRMED. Pastor Robert Adix stands behind the students who completed their confirmation class on June 2, 1963. In front of the pastor, from left to right, are Marsha Tuor (now Gross), Kathy Koch, Audrey Summerville, Tim Pederson, Terry Bottemiller, Sandy Thompson, Becky Gross (now Dierickx), and Jack Jennings. (Courtesy West Linn Lutheran Church.)

STAFFORD BASEBALL 1915. Pictured is the Stafford baseball team of 1915. Baseball was a popular sport to watch on Sunday afternoons. The team includes Joe Nemec, Bill Schatz, Ves Oldham, Leonard Thomas, Bert Schatz, Ed Robick, Harry Gebhardt, Albert Elligsen, and Lyle Tiedeman. (Courtesy Clackamas County Historical Society.)

BOLTON BASEBALL. A Bolton baseball team from the late 1920s or early 1930s poses, from left to right, in front of the Bolton School: (first row) Lester Melvin, Loun Clapp, Gordon Hammerle, and Harleigh Wright; (second row) Arni Vallein, Clarence Doty, Hubert Thompson, Frank Doty, Fred Reinke, and John Thompson. In the back is team manager Frank Hammerle, who was mayor of the city from 1925 to 1940. (Courtesy George Matile.)

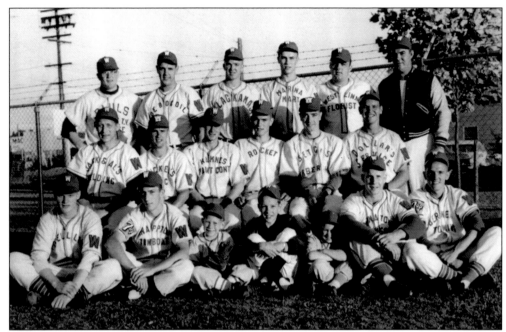

BASEBALL 1955. Pictured is the semi-professional baseball team from approximately 1955 that often played games at Willamette Park. From left to right are (first row) Red Bladel, Jon Webster, batboy Bob Dierickx, unidentified, batboy Eddie Dierickx, Dick Stevens, and Conrad Kilmer; (second row) Frank "Doc" Dierickx, Dick Schick, Dick Kaufman, Jimmy Ott, Don Rasmussen, and Gayle Perkins; (third row) Gordon Hammerle, Lee Wallace, Merle Stewart, unidentified, Bob Puterbaugh, and coach Glen Blair. (Courtesy George Matile.)

MILDRED YOUNGE. Mildred Younge is pictured here with her husband, Jack, in Willamette. Both active in the community, Mildred led the first West Linn Community Fair committee meeting in 1957, which started from a 1956 grange. She made the appeal to fellow grange members to have their Willamette Grange Fair reach a larger community, hence the name change from Grange Fair to Community Fair in 1957. (Courtesy Lisa Younge Lawer.)

BOY SCOUT AT THE FAIR. Scouts have been a part of the West Linn Community Fair since the start. Here a scout is seen leading the Pledge of Allegiance before the mayor takes the stand during the 1958 fair. Boy Scouts sold soft drinks and popcorn at the fair. The stand with the stairs was a portable bandstand. (Courtesy Lisa Younge Lawer.)

SCOUTS GATHERING. Members of both Boy Scouts and Cub Scouts in the West Linn area are active in community events, including this late 1950s or early 1960s Scout troop posing by the Willamette Primary School before the West Linn Fair. (Courtesy Lisa Younge Lawer.)

FIRST FAIR QUEEN. The West Linn Community Fair added princesses in 1959 to attract a wider audience. Pictured is the first fair queen, Bonnie Hunt, from Willamette, during the coronation. Other princesses that year were Linda Freeman from Sunset, Janet Boddy from Bolton, and Marilyn Berger from Wilsonville. (Courtesy Lisa Younge Lawer.)

CARS IN PARADE. During the first parade when princesses were included at the West Linn Community Fair in 1959, the princesses rode in style in Clem Dollar's convertible. (Courtesy Lisa Younge Lawer.)

FAIR COURT AND PARENTS 1961. Members of the 1961 West Linn Community Fair Court pose with their parents outside Willamette Primary School. (Courtesy Lisa Younge Lawer.)

TAP DANCING. Kelly Kordett's Korps prepares in the staging area of Willamette Grade School before marching in the first West Linn Old Fashioned Fair parade in 1958. (Courtesy Lisa Younge Lawer.)

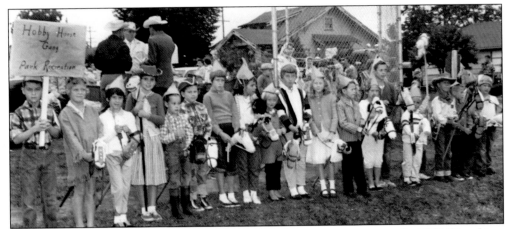

HOLLY HOBBY GANG. The Holly Hobby Gang prepares to race as part of a 1958 West Linn Community Fair event. (Courtesy Lisa Younge Lawer.)

1965 FAIR PARADE. Girls in a marching band display their baton twirling abilities at the 1965 West Linn Old Fashioned Fair. In the background is the Willamette Fire Hall. (Courtesy Clackamas County Historical Society.)

1965 FAIR. Donning umbrellas are members of the 1965 West Linn Community Fair Court. Queen Cheryl Savage (left), a Willamette student, poses with her fellow princesses. (Courtesy Clackamas County Historical Society.)

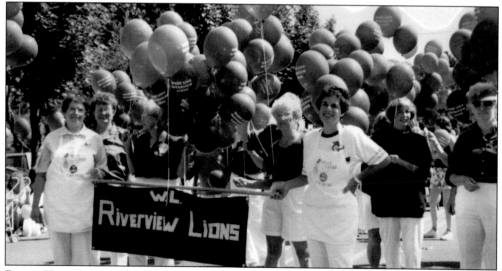

RIVER VIEW LIONS. The River View Lions have been active participants at the fair and are especially popular for their "Lion Paws," which they sell at community service events. (Courtesy Marge Logsdon.)

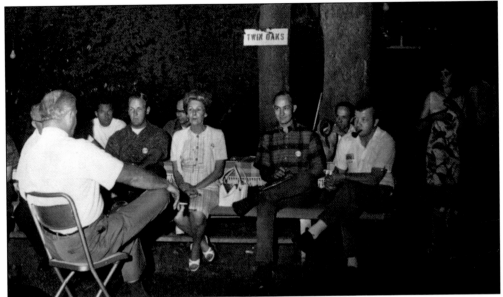

FAIR PLANNING. At the Twin Oaks woods outside of Marge and Walter Logsdon's Bolton-area home, Walter Logsdon (back to the camera), who was the president of the 1967–1968 West Linn Fair board, meets with other members of the committee to plan the fair. Included at the meeting were Ben Fritzsche Sr. (far left, half hidden), Marge Bucholz, Dale Perkins, and Judy Sellman (now Green, far right). (Courtesy Marge Logsdon.)

CENTENNIAL CELEBRATION. A group of men meets above the Willamette Fire Station playing cards to celebrate the centennial of Oregon in April 1959. Included is Jack Younge (standing left), whose wife, Mildred, helped start the West Linn Old Time Fair, and Charles A. Ridder, who owned Ridder's General Store, which is now Little Cooperstown. The men grew beards for their Oregon Centennial celebration and donned Oregon Centennial ties. (Courtesy Lisa Younge Lawer.)

LION BURGERS. The West Linn Lions are famous for their "Lion Burgers," topped with grilled onions and sold yearly at the West Linn Fair and in other locations. At the 2004 West Linn Old Time Fair, from left to right, are George Bernie, Mike Ray, Len McFadden, and Ron Adams flipping burgers. At the 2008 fair, the Lions sold 2,500 lion burgers in three days. (Courtesy West Linn Lions.)

BOWLING FOR A CAUSE. The winning 1965 West Linn Lions Bowling Tournament team poses, from left to right: Darrell Greenlee, Gordon DeBok, Don Schmeiser, Don McIntosh, and Charles Zacur. The bowling tournament is a way for the Lions to raise funds for the Lions Sight and Hearing program. (Courtesy West Linn Lions.)

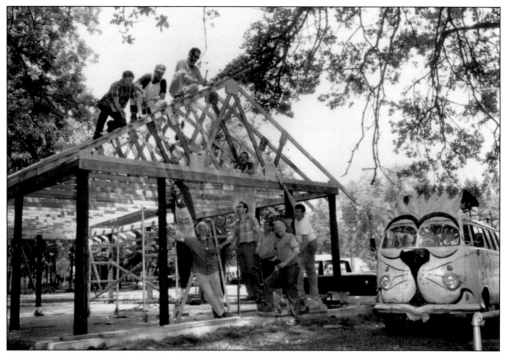

THE LION MOBILE. Traveling in style for their community service, the West Linn Lions once drove around in this "Lion Mobile" (right). The photograph was taken in 1974 at Hammerle Park, where the Lions helped build the current A-frame picnic area. (Courtesy West Linn Lions.)

LION AWARD. West Linn mayor Alan Brickley (right) and West Linn Lions Club member and White Cane Drive chair Bob Koppler (next to Brickley) are shown in 1979 at city hall during a recognition proclamation given by the city to the West Linn Lions for their community service. (Courtesy West Linn Lions.)

FIFTIETH ANNIVERSARY OF LIONS. The Lions celebrated 50 years of service to the community in this 2003 celebration for members held at the Willamette Valley Country Golf Club in Canby. Included in the photograph are three living charter members: in the front row, fourth from left, is Dale Liberty; fifth from left is Dwight Catherwood, and eighth from left is Harold Gross. Also shown are, on the back row, (far left) Gary Eppelsheimer, (third from left) Terry Neil, and (fourth from left) Mike Watters. (Courtesy West Linn Lions.)

FIFTY YEARS IN COMMUNITY. West Linn Boy Scout Troop 149 has been active in West Linn for over 50 years. Here they are seen at a 1975 campout doing the flag ceremony. Randy Tomsik (right), who was a student during this campout, went on to lead the troop as scoutmaster from 2000 to 2005. Jay Allison (second from left) and Howard Larson (third from left) are also shown. (Courtesy Alan and Elsie Lewis.)

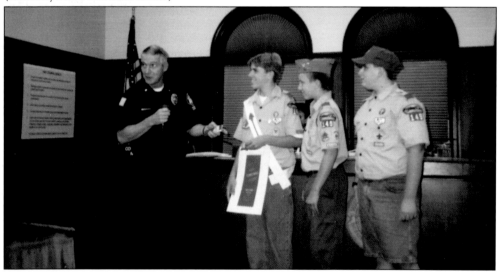

CAUGHT DOING GOOD. West Linn police lieutenant Larry Gable is presenting members of Boy Scout Troop 149 the "Caught you doing something good" award in 1997. Sean Watters (second from left) and other Scouts receive the award, something the West Linn Police Department still does. (Courtesy Mike Watters.)

PASSING THE BATON. Scoutmaster Alan Lewis, who led West Linn Troop 149 in 1972, passes the baton to the new scoutmaster Stan Gump. Lewis is now a West Linn Lion, which has sponsored the Scouts for years. (Courtesy Alan and Elsie Lewis.)

CHARTER NIGHT, RIVER VIEW LIONS. Marge and Walter Logsdon pose in at the banquet table on the charter evening for the River View Lions in 1992. Walter Logsdon was an original member of the West Linn Lions Club, which formed in 1953, and sponsored the River View Lions in 1992. Walter was also scoutmaster of West Linn Boy Scout Troop 149 from 1953 to 1958. The West Linn Lions sponsor the Scouts. Marge Logsdon was a teacher in West Linn schools from 1946 to 1982. (Courtesy Marge Logsdon.)

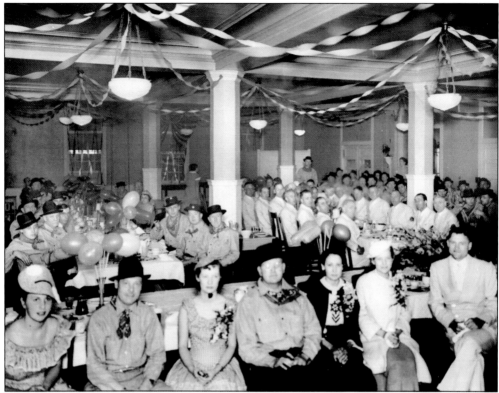

TERRITORIAL DAYS. The West Linn Inn was host of various celebrations, including this Territorial Days banquet in 1935 celebrating Oregon City's history. The West Linn Inn was built in 1918 to house paper mill workers and included a restaurant overlooking the Willamette River. It was torn down in 1980. (Courtesy Clackamas County Historical Society.)

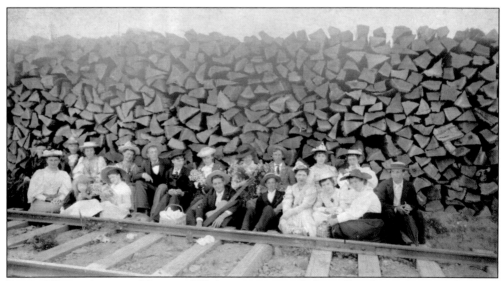

PICNIC WAITING FOR THE TROLLEY. While waiting to catch the trolley, these young people decide to have a picnic in the early 1900s. (Courtesy Clackamas County Historical Society.)

SCOUT SHACK. Once a popular spot to purchase snack items at Willamette Park, the Boy Scout Snack Shack was torn down in the late 1940s. The current stage at the park sits in its place. (Courtesy Dave and Judy Shipley.)

LOCKS FESTIVAL. Begun in 2004, the Lock Fest (below) is now a popular West Linn tradition in the fall, allowing people a close-up experience of the 1873 Willamette Falls Locks and Canal, which the U.S. Army Corps of Engineers owns. The crowd on the left is listening to U.S. representative Darlene Hooley during a ceremony in which many local officials voiced their support for the locks. The 1922 Oregon City–West Linn Bridge is seen in the distance. (Courtesy Willamette Falls Heritage Foundation.)

BIBLIOGRAPHY

Clackamas County Cultural Resource Inventory: West Linn Study Area, Clackamas County, 1984.

Geldaker, Kris A. *Hometown Study—West Linn Oregon*. West Linn: West Linn High School, 1980.

Goetze, Janet. "Old City Hall Goes Down in West Linn History." *The Oregonian*, October 14, 1999.

Historic Bolton Neighborhood Walking Tour. West Linn: Bolton Neighborhood Association, 2008.

Historic Survey. West Linn: City of West Linn, 2006.

Klatt, John. *West Bank Stories*. West Linn: Self published, 2008.

Lange, Erwin F. *The Willamette Meteorite 1902–1962*. West Linn: West Linn Fair Board, 1962.

Stuckey, John D. *Historical Development of the West Linn School District*. West Linn: West Linn School District, 1974.

Thompkins, Jim. *Oregon City*. Charleston, SC: Arcadia Publishing, 2006.

Walking Tour, Willamette Neighborhood Association. West Linn Chamber of Commerce and Clackamas County Tourism Development Council, 2008.

Welsh, William D. *A Brief History of West Linn and Oregon City*. West Linn: Crown Zellerbach Corporation, 1941.

West Linn Bicentennial Committee. *Just Yesterday: A Brief Story of West Linn, Oregon*. Portland: American Revolution Bicentennial Commission of Oregon, 1976.

INDEX

DISCOVER THOUSANDS OF LOCAL HISTORY BOOKS FEATURING MILLIONS OF VINTAGE IMAGES

Arcadia Publishing, the leading local history publisher in the United States, is committed to making history accessible and meaningful through publishing books that celebrate and preserve the heritage of America's people and places.

Find more books like this at
www.arcadiapublishing.com

Search for your hometown history, your old stomping grounds, and even your favorite sports team.

Consistent with our mission to preserve history on a local level, this book was printed in South Carolina on American-made paper and manufactured entirely in the United States. Products carrying the accredited Forest Stewardship Council (FSC) label are printed on 100 percent FSC-certified paper.

MADE IN THE USA